D0087184

A PAUSE ON THE PATH

Visual Studies, a series edited by Douglas Harper

A
PAUSE
ON THE
PATH

Ronald Silvers

 Temple University Press / Philadelphia

Temple University Press, Philadelphia 19122
Copyright © 1988 by Temple University
All rights reserved
Published 1988
Printed in the United States of America

The paper used in this publication meets
the minimum requirements of
American National Standard for Information
Sciences—Permanence of Paper for
Printed Library Materials, ANSI Z39.48-1984

Library of Congress Cataloging-in-Publication Data
Silvers, Ronald.
 A pause on the path.
 (Visual studies)
 1. Ladākh (India)—Description and travel.
2. Ladākh (India)—Description and travel—Views.
3. Buddhism—India—Ladākh. 4. Buddhism—India—
Pictorial works. 5. Silvers, Ronald—Journeys
—India—Ladākh. I. Title II. Series.
DS485.L2S55 1988 915.4'6 87-33646
ISBN 1-87722-559-1 (alk. paper)

To the Villagers of Hemisshukpachan
and the Lamas of Ridzong Monastery,
who showed me a world that is otherwise

The reader may find the following:

A PAUSE ON THE PATH

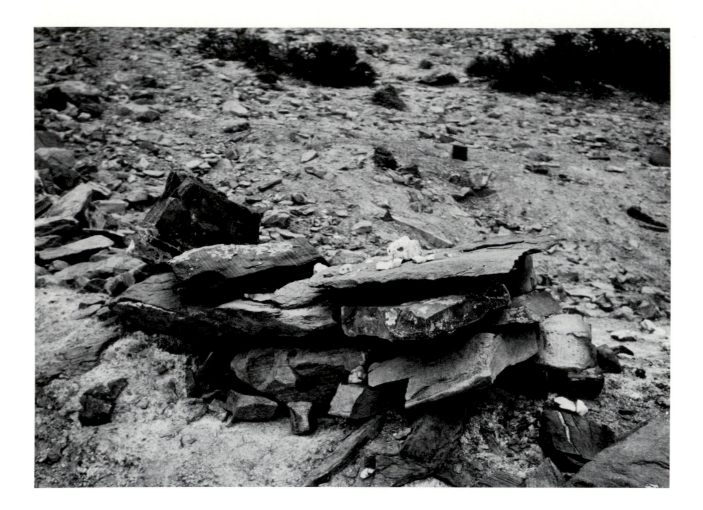

2 .

A Pause on the Path
Prospect:

I leave the bus at midday. From Leh to Hemisshu, a six-hour ride over fifty-five miles across the mountain passes of the terrain of the Tibetan plateau of Ladakh. Hemisshu: a station along the highway where you can store your bags; a single building that also serves as a tea stand containing a porch furnished with one mended and two broken chairs.

I cross the highway for my walk to the village of Hemis-shukpachan, some five miles through the mountains, a steady ascending grade. The first few hundred feet are close to a rapid river of glacier water that I will follow at an increasing height, always parallel to the path. Also in the first few hundred feet of the path, rocks underfoot are held by chain-linked wires that prevent them from sliding away, falling down the side of the mountain into the river.

Then the steep climb begins. As it does, the path all but disappears amidst shale and small stones of the mountain. Here, walking alone, without the sound of wind or animals of the land and village, there settles a rhythm of walking that finds its place with a rhythm of breathing. Time fades. I cease to think of the trip or the family in the village with whom I live. Automatically, I follow the path made by other travelers. My attention is concentrated on the line of this path, and only occasionally does my gaze drift to either side of me.

And then, involuntarily, I look upward, pause in my movement. And there high above me to the east, a form of rocks, jutting out of the earthen mountain, isolated. Hard rocks, they appear wet in this dry desert. I gaze at them. The small camera I have carried in my hand is before me. Without

thinking, without composing or judging, I release the shutter. The pause terminates with the shutter's sound. This sound, unlike the roar of the glacier river below, is a source of awakening to the nonaction of the pause. All has happened to me. All of the visual has passed through me. I continue on the path, momentarily wondering how long I had lingered. But the pause was there, and now in returning to the action of walking, I have only what the film has received from the light upon the mountain; I have only the reflection of the light from those rocks upon the film. My presence was not settled in my lingering. The pause was but an opening for the form of the rocks, from the surprise of their appearance. Now that that appearance has passed, so too the opening is gone, so too the suspension of movement and time has slipped away. I can rely only on what my film will tell me of that lingering. Only as I develop the film three months later will I be able to resee the presence of the vital form of the rocks and will I be able to visit anew that experience.

For the pause is a special moment that cannot be held in thought or imagination, or even in the sentiment of my body as memory. The pause is only about in my quiescence, only as I move from the animate to the inanimate, only in the conjoining of myself with a vital form. Even the use of the camera in the pause is, paradoxically, a part of the suspension of action. The camera becomes functional as a source for the still photograph, and therefore its operation is an achievement of a "still" movement. Within the pause, the camera receives a vital form, just as the eye and the rest of the body receives such form: without discrimination, without a code of meaning, without intention. If the camera were not in my hand at the place of the pause, if I had to check or advance the film, or if I had to calculate the light, a foreignness of operation would turn me from pause

to action. If I began to *take* a photograph, the camera would become an instrument to reach out to the rocks above, to record my purpose and vision, violating the vitality of form; then the image upon the film would become no more than a sign of my own consciousness, my mark upon the landscape of the resulting photograph.

Always the pause is born from a rhythm: my rhythm of walking through the mountains and villages of Ladakh, a rhythm of my body as it conjoins with the rhythms of the bodies of Ladakhis at work or in prayer. Always those rhythms give way, cease their pattern, suspend their tonality of gesture to release a line of light that I follow into form. This form is for me a transgressing of histories, allowing a resonance and singularity of my person with the appearing form. Here, for me as photographer, the vitality of portraits of people are not "caught." Their gesture is not motion frozen, but a line of light, complete, whole, in a unity of their attention with mine to reveal a vital form. Vital refers to the life giving and life receiving of these forms. They are vital in a "still" attention, an attention unmarked by purpose or reflection. The light of a vital form is written upon the receptive, the stillness of film, as the shutter door opens in front of it, and again, as the light passes through the negative to a receptive silver of the photographic paper for the print.

Here, as photograph, the life giving of a vital form is an expression surrounded by words, creating a photographic essay. A pause on the path in Ladakh is repeated over and over as it may be found by me, then upon film, from that film to paper and from the many papers with accompanying words into an essay for the reader. This long sequence marks at each point the potential of the pause to offer itself again, longingly searching for a receiver of its potential.

A pause on the path begins with a lingering within a journey through the Tibetan plateau, a journey through three summers of my wanderings, from village to village, from monastery to monastery, from person to person. This journey continues with a photographic essay. This book you are holding has been shaped to allow you to receive life forms from Ladakh. The words of the written text offer an occasion for meditation upon the visual appearances rather than saying what these forms mean for me or for others. All force behind visual and written expression of the photographic essay must be absent in order to permit the inanimate of this vitality to eventually find itself to a person as receiver. The pause is a rest from motion, wherein is found a harmony of life, a harmony between what is within and what is without. Here in this photographic essay is a journey through an unfamiliar life-world, yet one that I and others already know. Therefore, what we may receive in these images needs no termination in what they signify. The journey through a familiar/unfamiliar world is sustained by the pause, and the pause is sustained by such a journey.

Ladakh, in words and images . . .

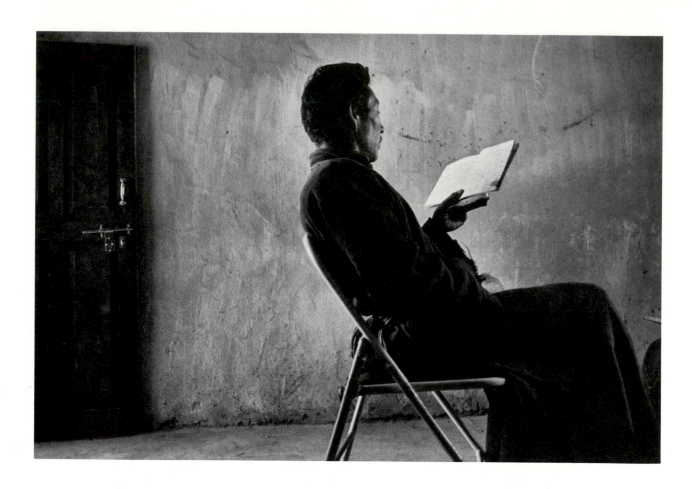

8 •

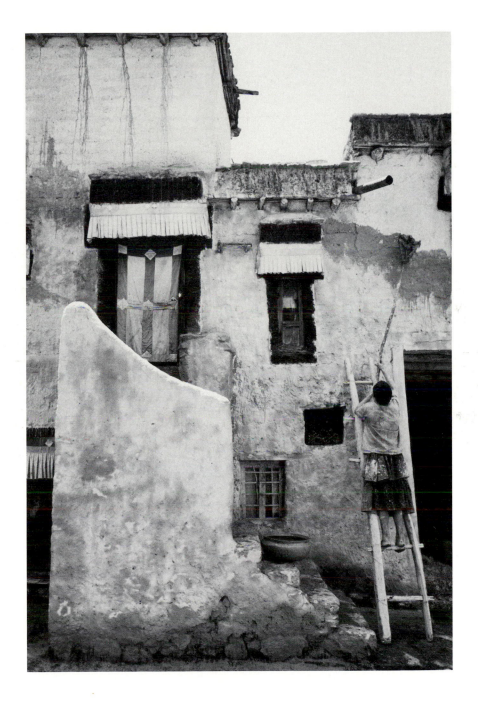

9 .

PROLOGUE

Ladakh:

Latitude: 34.00 North Longitude: 77.00 East
38,000 square miles
7,400 to 23,800 feet altitude range

Population: 132,299 (1981 census)
Language: Tibetan dialect

Regional government: the state of Jammu and Kashmir
National government: India
Bordering nations: China, north and east; Pakistan, west

when traveling, I repeatedly encountered
among people and myself, a pause

their pause,
an arrested movement between
a gesture completed and a gesture to come,
when their body does not relax
but expresses a bond
of their physicality to an external materiality

my pause,
among the steps of my journey
within a desert
without a context and history
I become a witness to an image
brought about by intimacy and distance,
created by passion and stillness

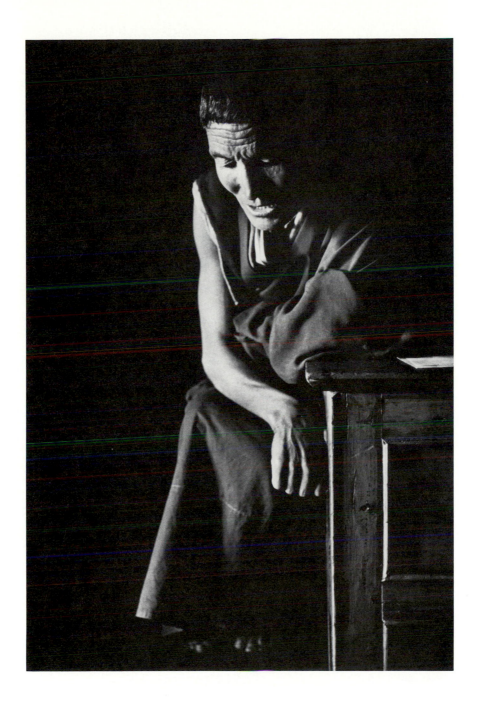

from my gaze as photographer—
an unseen image comes to rest
upon the imagination

it rests there until
when processing and printing the film
there is a first sighting of an image

seeing but not imagining
I compose words
of a photographic essay
allowing the image to return
to the imagination

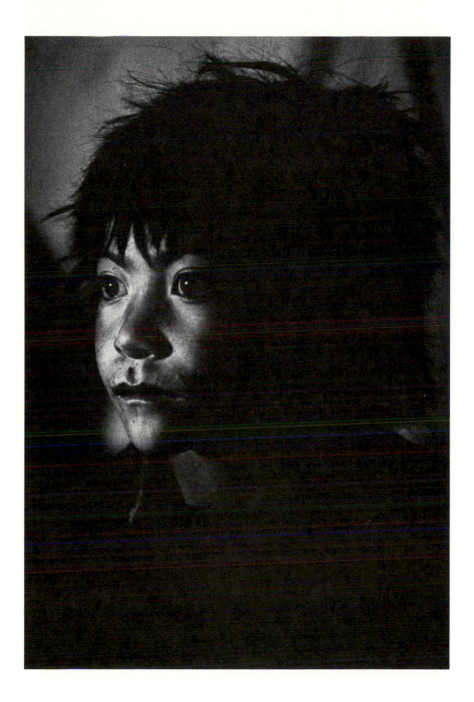

17 •

Fragments/Totalities

In the frame of the camera: Peripheral objects circulate un-
examined until the camera centers and begins to follow: I
do not see this moving object symbolically: Yet I view it
attentively: Attached to a field of vision: As part of that
field: The duration of focus: The moving among points:
The locus of attention.

And then: Within that locus: Loss: In that attention: *Silence*:
Absence: The source of wonderment absorbed: The shape
of attention announced: Outside: Distance: Limit: Hidden.

A void of silence yields an experience of loss of presence:
Yields a need for a meaning of presence: Not seeing a total-
ity in which meaning is realized: Seeing only fragments:
Only details of images.

He sees for showing them in him:
He is what the rock says:
The leopard: Death in dance: In devour:
The dancing men: Bedecked women: Lolling children.
Hunting not gathering he gathers into sigh: Into sight.
What can there be to disagree about?
He hears them breathing audible breath.
He hands over pictures:
Or does he?
Innocent stranger:
Or is he?

Fragments: I offer no more: And no more resounds: Invis-
ible: Each point of attention: A shape constrained: Taking
hold: The loss.

A path I face in silence has no mention within silence: I
leave: Search so as to find the source: Resaying a point
between outside disturbance and the path: A point be-
tween: A point outside.

I lose sight: It is here: The boundary again: Necessity pointing: Pointing or bending back to return: Estrangement of meaning provided: Permitted to move back in order: And further and equal: Fragments: Totalities.

There is in silence and myself one ground:
A growing order left the attempt and looked to the focus.

There is in silence a growing order: There is in silence a task between self and self: I am aware: Drawn into the difference called for in moving: Between inscribing and reading those inscriptions: As an account is not only an account: But also shadows expressing muteness: This essay: These words: These images: As continuous action: As parts gather together into a totality: This gathering reflects a shape of attention that I discover/construct as a way of reaching beyond my boundary of understanding: Reaching beyond without any existing sign of shared understanding: In this reaching my attention becomes a design for meaning.

There is in silence: A loss of substance.
A pause on the path: Mountains disappear.
In silence: A discovery of form.

A photographic essay: Never one thing: Never one object: A range of potential: Successive possibilities suggesting themselves: Belonging to an immediately and constantly changing world: Action takes the course of potential offered and movement comes to fruition in images and words other than originally intended.

There is in silence: A loss of form.
A mandala burns: A ceremony disappears in smoke.
In silence: A discovery of pure attention.

to visit cannot be held; source; achievement; just as the eye so the body; the door moves in front.

Gesture, sign, presence, landscape: these are the moments of awareness and attention that form a silent matrix for the experience of *A Pause on the Path*. The text transcribes the verbal interaction with images and composes a way of telling that interrupts the sequence and breaks the cohesion of the narrative form.

Upon these pages, the text displays different voices of the author: voices inscribed in size, shape, and spacing of script to allow a movement among expressive sources, to allow pauses for reflection, and to allow yet other fragmentations of the text.

all happened; the pause; rocks opening; this long sequence Ladakh.

estrangement of meaning provided; permitted; and further and equal.

Within both images and text, consider the angle of the glance and the poise of hands at rest as well as in activity; the specific person is in communicative collusion with the landscape and the signs for human presence form gestural analogues for ritual and language. Without "having" the language, text plus image combine to elicit language from the reader by bypassing the sound of the author's voice.

the task in between self and self again; account is account and drawn into the difference.

Looking through the text and looking through the images in this case come very close to the proximate activity of composing and completing the book as a whole. In reading the essay, reading happens as language and image speak to each other; here, the mind of the attentive reader creatively makes sense, as sense occurs.

Gestures of images and text of the essay form a matrix for sense rather than a justification for outlook and opinion. Here in this photographic essay there is no sanctioned trespass.

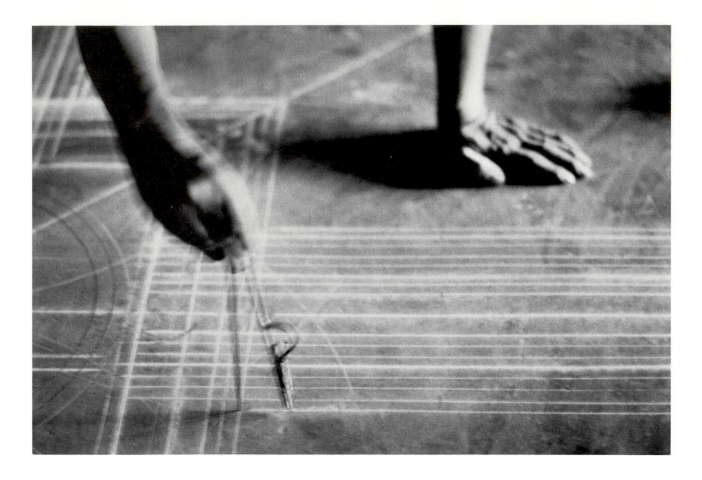

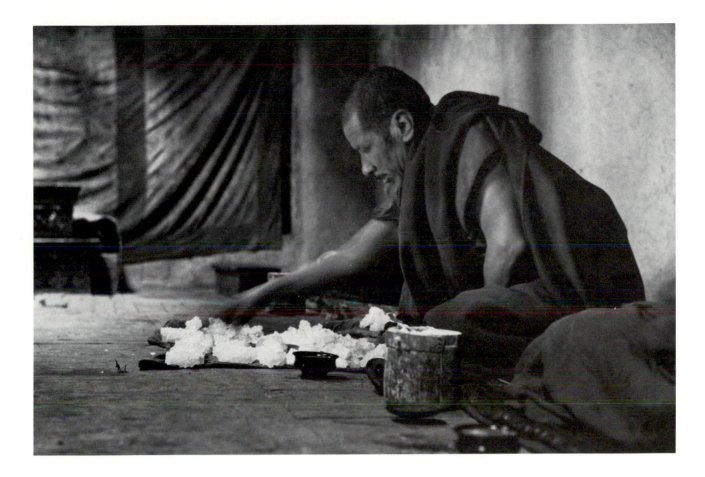

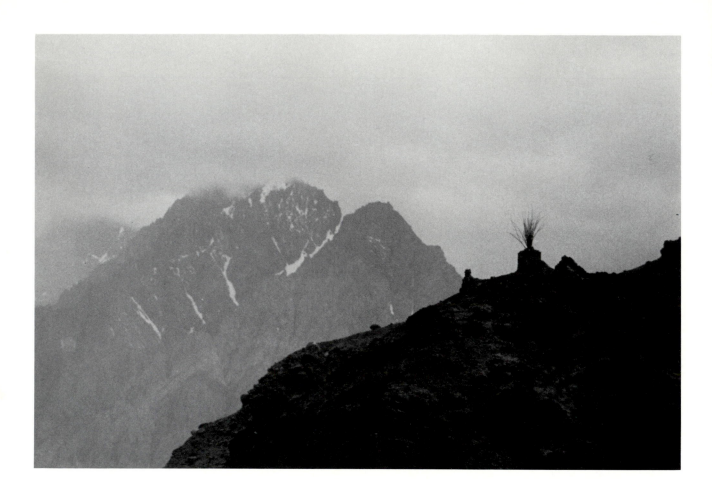

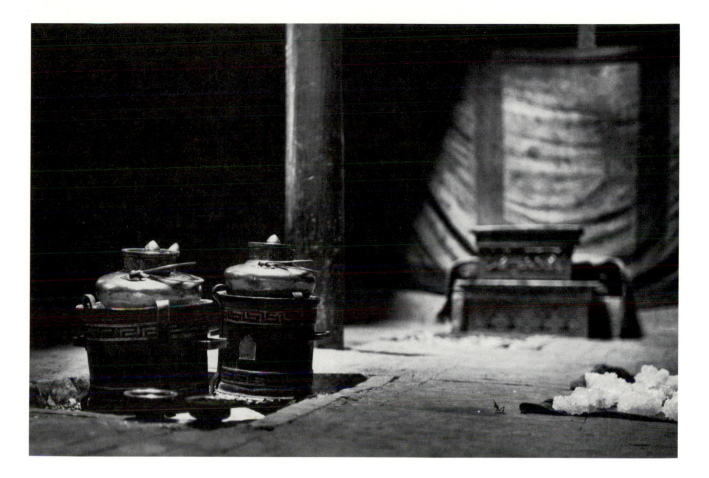

hard rocks appear wet; dry desert awakening; all has happened; the pause was there; the light from those rocks; opening; lingering to visit; source and achievement.

just as the eye; so the body; without hand; mark; give way. cease. suspend. release.

Within the gaze attention is not upon but around a person: It settles upon an area of space containing people and objects but does not center upon any specific one of them: Within the region of the gaze a person may change positions: Engage in an activity and still retain privacy: One may even move undetected out of the field of the gaze.

The gaze is an intense passionless look: It does not emerge from curiosity nor from a hunger for what is seen: For the gaze is an attention without control: An attention that does not seek what it receives and accepts.

to visit cannot be held; the door moves in front surrounded by words; film; paper; many papers.

The gaze upon the face of another is always found in the reflection of that look upon one's own face.

this long sequence; three summers Ladakh.

I came upon a young boy shepherding two small cows as I was photographing a large *mani* which is a prayer stone: He stood as the cows rested and grazed: We looked: I through the viewfinder of the camera: He toward the camera and me: We looked but I felt neither observed the other.

a single line; a person may change; two broken; one mended; children appeared.

Later two other children came: And I put the camera away: It was from them and not from him that I heard the shouts: One photo! One photo!

his eyes were elsewhere; always at rest; I cannot tell; a pause on the path.

As I turned toward their direction they shyly disappeared behind the *stupas* which are cylindrical mounds that serve as shrines.

release of the shutter; check and advance; together in sequence; a pause on the path.

The boy did not retreat: He sat on a boulder as I leaned against another large rock some twenty feet away: We gazed at each other and occasionally the other children appeared and shouted to him and disappeared again: He spoke back to them but never moved his head or eyes from my direction.

He sat on the porch of a Buddhist school located on the outskirts of Leh: His classmates had not yet come: We looked into each other's eyes for many moments: For each there was the other.

As I stood there I found his look neither took: Observed: Nor gave: Told a feeling: I wondered about my own look.

after images; the stove is an animal; the roar of the glacier; the first a spinning; attention unmarked.

Later I offered him a small shell: He accepted it only after a teacher told him that he might have it and then he did not look at what it was for some time: When he did look he but glanced at it: He moved the shell with his fingers: He felt the shell but his eyes were elsewhere.

a small shell; never again; the first is a spinning; within that light; a pause on the path.

This year I am aware of afterimages that appear following the times when I am photographing: From an afternoon visit the grandmother's face stays with me now strongly: But there in the house I had only glanced at it: The glance had been a light look: A look so quick that I and others had hardly noticed that my attention had settled: Yet that light glance now brings a message in an afterimage.

the mood of; mind is not; the mind minding; you hear yourself speaking within that light.

the mountains stride stones bleed cry shriek within that light; the small shell; iridescence; the mood of mind returns; an anticipation.

We witness a person's aura when she or he pauses from labor and from engagement with the world: In this pause from a released attention the light of an aura is emitted.

27 •

the stove is an animal; the roar of the glacier; the first is a spinning; attention unmarked.

There is here a photograph of a family: An image that emerged during my long sitting with them when each ceased to speak but when each was aware of the presence of the other: As I sat within the family's kitchen: I was aware of an aural presence that did not possess a single source within that moment: Within that pause there was no tension of bodies or separate activities: Within that light I was aware of a confluence of auras separate yet together.

two broken; one mended; ascending the glacier; falling down without the sound; I follow.

She accompanied a man who came to my room inquiring about my tape recorder: I anticipated from him as from other Ladakhis his desire to have his singing of songs recorded: But when I turned on the tape recorder this man spoke into the microphone: It was a long talk and although I could not understand his words I recognized in the melody of his speaking a returning theme that had many variations.

As he spoke I realized he was a storyteller: He offered but one tale: When it was completed he smiled nodded to me and left.

small camera; source; achievement; within that light; the long sequence; return.

Later in playing the tape to a Ladakhi friend I was to learn that the story told by this man was the story of the life of Buddha: Much later I was to learn that this man had been a Lama but one day he left the monastic life to return to the village: And though I visited the storyteller's home and met his wife I never again encountered this woman and child.

Hard rocks appear wet: Dry desert awakening
all has happened: The pause was there.
The light from those rocks opening,
lingering to visit.

Source: Achievement
just as the eye: So the body
without hand: Mark
give way. Cease. Suspend. Release.

The visit cannot be held.
The door moves in front surrounded by words.
Film, paper, many papers
this long sequence: Three summers Ladakh.

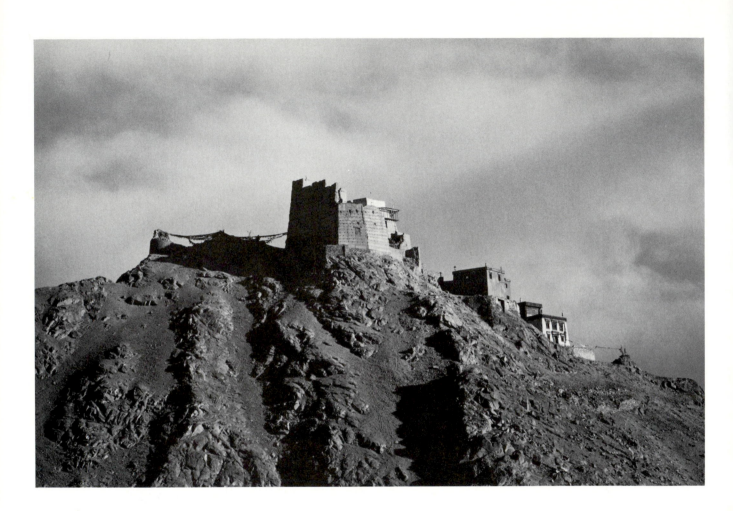

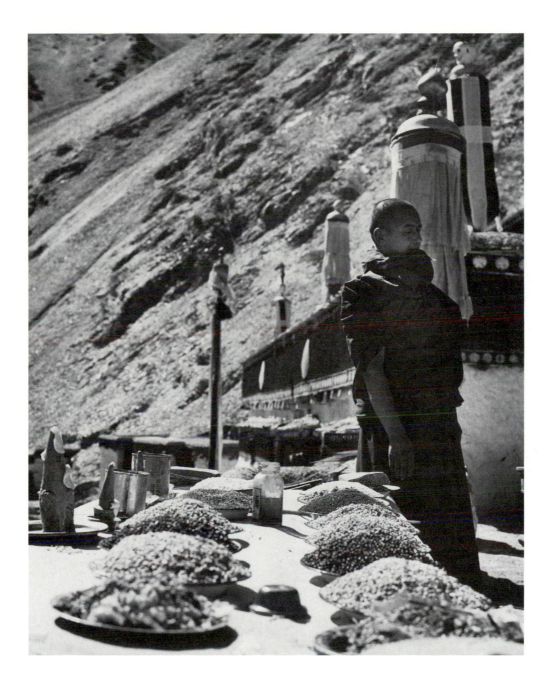

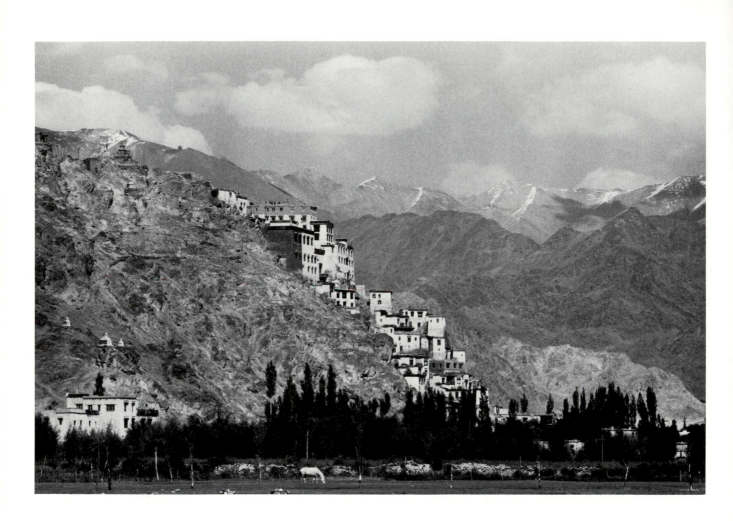

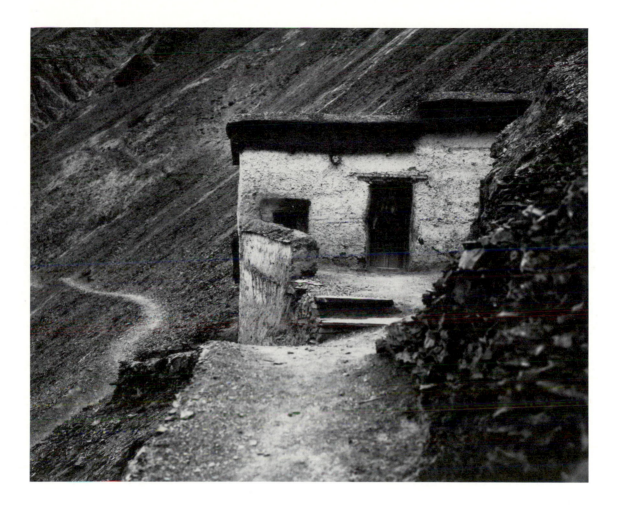

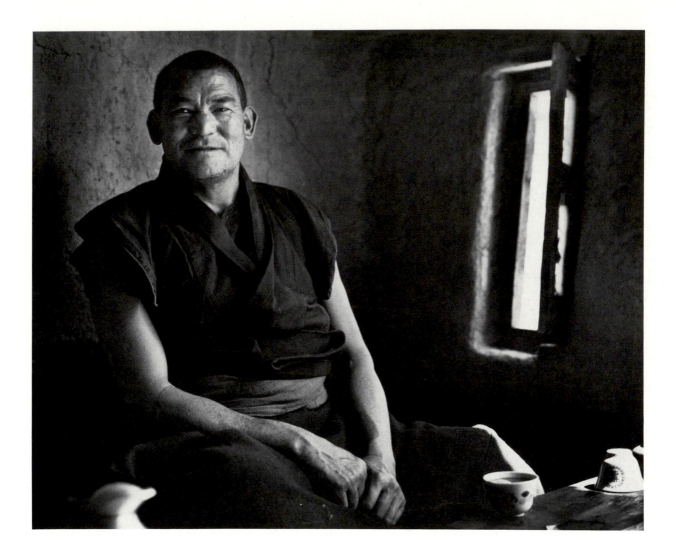

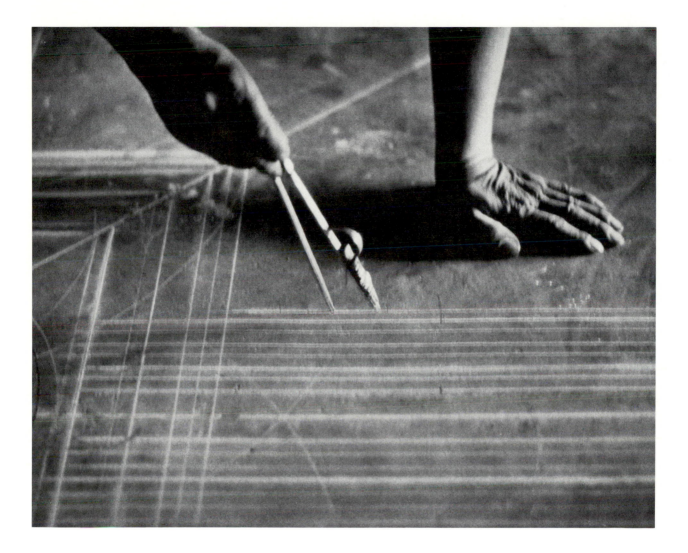

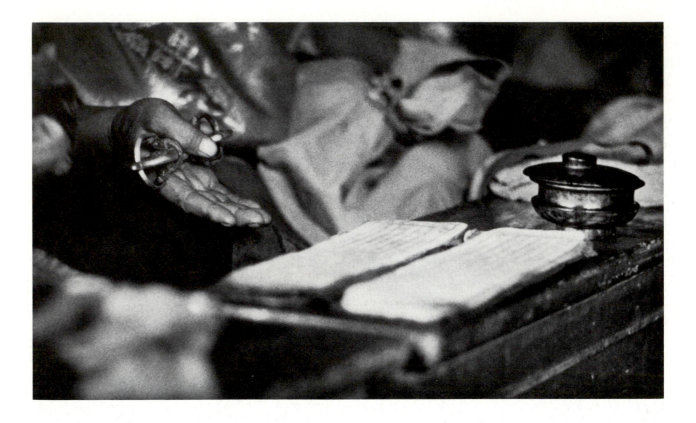

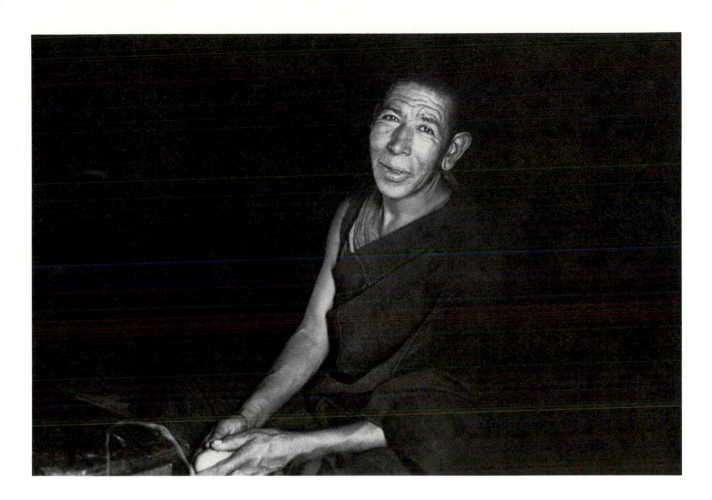

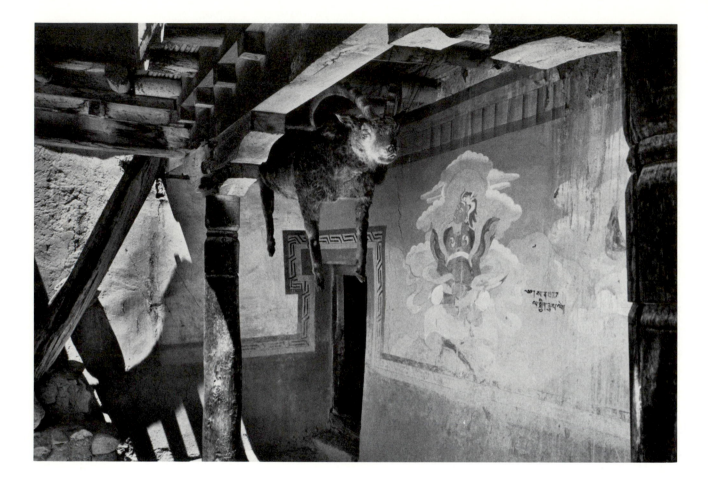

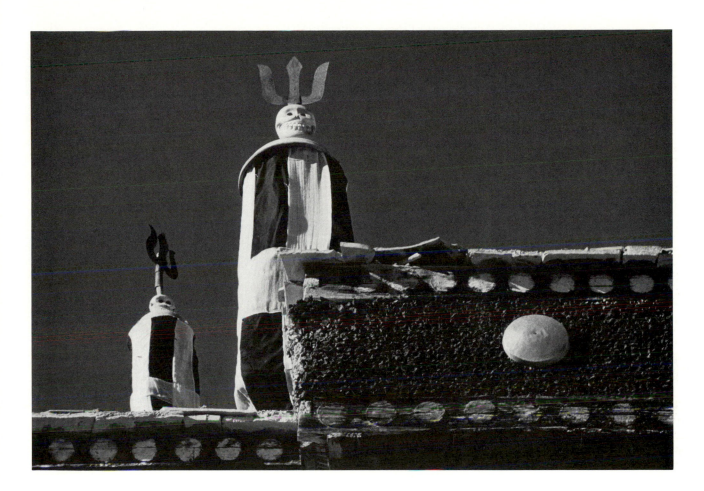

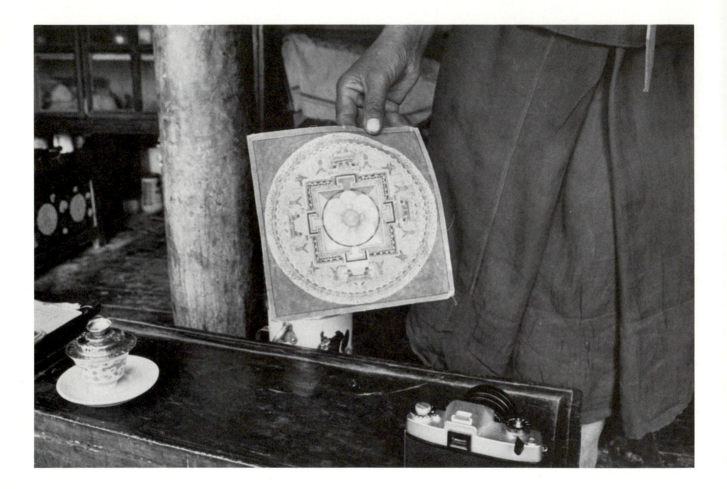

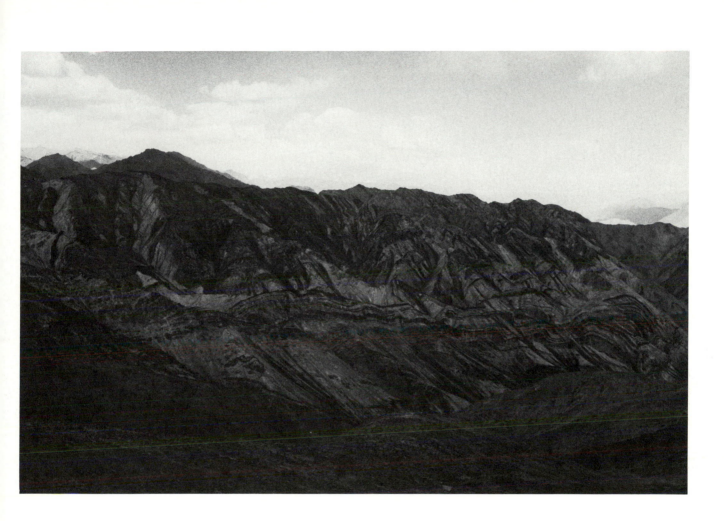

43 •

walking

I am aware of my body in Ladakh by my effort to do what elsewhere are simple and easy tasks; walking is one of those activities.

A Second Entering

We enter Ridzong Monastery after a tiring half-day journey from the village of Hemisshukpachan. The donkey was unwilling to go part of the way and we unloaded the bags and began carrying them up the mountain to the pass.

The Lama whom I had met last year when I first visited Ridzong greets us and takes us to his quarters.

For some time the Ladakhi man from the village, the Lama, and I sit together. There are no words. Then the conversation begins. There are long pauses. Sometimes a few minutes pass before the next words are uttered by the Lama or by the Ladakhi man.

The Lama leans forward, his elbows on the small table before him, his head upon his hands, his eyes not "looking" at us or anything else.

The man from the village tells me that the Lama wonders why I wish to stay at Ridzong for a long time.

My journey to Ridzong
to find a monastery
in a desert

*everywhere in Ladakh the land moves up and down; even
on the floor of the valleys it is unusual to find an extended
flat surface without rocks or boulders.*

A Lecture in Pantomime

At the end of a lunch and prayer ceremony the Little
Lamas brought a large cloth filled with rock sugar crys-
tals. At first, I did not know what these crystals were.
They were broken into pieces and we were each given
a serving. When I returned my portion to the Little
Lamas they stuffed these pieces into the folds of their
robes. Later in the temple as the Artist Lamas of the
mandala rested from their work, the Head Artist Lama
of the mandala offered me some of his sugar.

*at the beginning of a walk my attention settles upon my
muscles, the water bottle slapping against my leg, even the
press of my hat absorbing the sun's heat; they are immedi-
ate, obscuring the visual.*

I refused his gift. With surprise he showed me that the
crystals were to be eaten with tea and he displayed his
enjoyment in having them together. I told him *tsok-po*
(bad), and then began to explain in gestures that sugar
was harmful to the teeth, to the heart, and that it would
give not only sudden energy but also lead to sudden
tiredness. Not knowing the Ladakhi words, I panto-
mimed teeth falling out, alertness and tiredness, and
finally death—falling to the floor with my tongue hang-
ing out of my mouth as I had seen played by a child in
a village.

When I had finished the Head Artist Lama's eyes grew large. In one quick gesture he gathered all his rock sugar crystals and threw them out of the open window. Then we all rolled on the floor in laughter.

as I continue to walk, this acute experience of physical effort fades; attention to body is released slowly, extended first to the steps I must take, then further on, to a path before me, and finally to a path that disappears among the rocks and bend of the mountain; this outward movement leaves behind the physical strain, the experience of thinness of the air and high temperature.

A Quartz Crystal

Often we would meet by chance on the steps, veranda, or outside the kitchen of the monastery. He would call out his first name, "Saltan," and after a few moments, I would respond with his last name, "Gatso." Then we would laugh and throw our arms around each other.

One morning, as we were both in the temple while the Artist Lamas of the mandala were working, he laid down to sleep with his head in my lap. I saw again, the swelling on his cheek that he had pointed to a few days earlier. He had touched it then and had said, "*Zermo*" (pain), and I asked him to pull back his lip to see at the gum an abscessed tooth.

While he slept this day I took a quartz crystal I had carried to Ladakh—a crystal that I had held during the *pujas* (prayer services), that I had shown to each of the holy people I had met (so that they might touch it)—I took this crystal and placed it just above the swelling of his cheek. He woke quite soon after. Later that morning he came to me with a smile, holding his hand to his cheek. *"Zermo met"* (no pain), he said.

I did not know then, nor do I know now with certainty, whether there was a connection between my act with the crystal and the loss of his pain.

then this sphere of awareness slowly extends to the land around the path; the path as walkway demands constant attention so that only peripheral vision or quick glances may allow me to witness the sides of sweeping mountains or down some two or three thousand feet to an accompanying stream.

Preparing for a Journey

From Ridzong I take a bus to Leh, and from Leh I share a taxi for a two-day ride down the mountains to Srinagar.

In a marketplace in Srinagar, in the midst of a crowded street, I notice three Theravadin Buddhist monks in saffron robes. The eldest holds a bowl. He stands in front of an open stall that serves food. The owner shakes his head, no. There is then, as when the monks first stopped at the stall, no change of expression on their faces. Their eyes are unladen and I find their look as one of pure attention to whatever is around them. They pause with one of them holding a bowl, but their eyes neither ask nor invite.

As they turn away from my direction and continue down the street I feel a movement in my still body. I feel (anticipate) lowering my side, allowing the camera bag that I carry (and that contains my passport, airline ticket home, and money) to fall from my shoulder to the sidewalk. I feel my legs wanting to move in their direction. I know that if I follow them I will complete my journey. I feel all these movements in my motionless body, as the three monks pass out of view.

keeping this field in partial attention as I move leaves me suspended in space; the path, as path, is always the same; it is the area of partial attention beyond the path that surprises and delights; the mountains seem to change with each advance of the walk; the eye wishes to stay with the scenery, but the hazards of the surface—the unsecured rocks, the water over the surface, its narrow walkway or no walkway at all, the bridges of a single thin log—all demand that the eye receive only a residue of the landscape.

Tibetan Lamas

Two Tibetan Lamas are at Ridzong during my stay. They are Teachers of the Mandala, sent from Gyudmed Tantric College to instruct and assist Ridzong Lamas in the making of the mandala.

In the temple in which the mandala is being made the Lamas joke with one another and point out to me the images they design in the sand: a monkey climbing a tree, a head of a monster, a skeleton. Then one of the Tibetan Lamas invites me to his room. As we arrive he seats himself on one mat, and I take a seat on another mat. No conversation takes place either between him and the other Teacher of the Mandala or with me. Instead this Lama serves me tea and dried apricots, and then he begins to meditate.

The room is high in the monastery, and there is a draft to the left of where I sit. I search for my quartz crystal in my vest pocket that faces the drafty window. The crystal is hot to the touch, as it was a few days earlier when I first sat in this room. But in my own room or in the temple, this crystal is normally room temperature or even cold.

On the other side of the room from me the older Lama reads his religious texts. To my left the second Lama closes his eyes in meditation. His body rocks slowly, sometimes from side to side, sometimes forward and back.

here, time is suspended; here, I lose all sense of time's movement; if I check my watch, I find that a half hour or an hour has passed, and I cannot account for such passage.

at these times, on these walks, solitude—the absence of others—frees me to be spatially suspended; no monitoring of speed or coordination and, above all, no speech releases me to "drift in space."

My own body relaxes. My state of mind is calmed by this room and these movements. There are only the sounds of breathing, pages turning, and an occasional clearing of one's throat.

We three sit in this room without conversing. After almost two hours we are interrupted by the serving of lunch.

Later, I realize that without prescription, I have been instructed in meditation.

but then, late in the walk, physicality returns; when I have run out of water, when dehydration has begun, when my strength is running low, when my breathing and pace register fatigue, attention leaves the surround of the path and returns to the confines of the body in a more pressing way than at the beginning of the walk; the path itself is broken away from focus, becomes separate, appears a hazy obstacle.

here, all becomes limit, boundary; I feel a new suspension, a remoteness from the surround; the limit of the body imposes itself, obscuring the landscape; my mind now turns to calculation; how far, how steep the grade, how late in the day? physicality is translated into function; that of the effort ahead, of steps, of lifting my body and accompanying backpack higher, of positioning of feet to break a steep downward movement.

at this point the mind returns; function calls upon it, not in reflection or wonderment, but for pragmatic need; the physical is snared by the mind to which it gives authority; the glow of attention dims by the demands of continuing my journey.

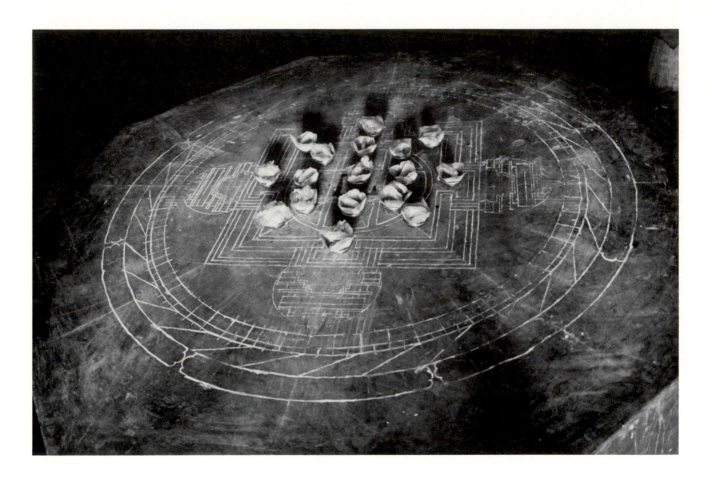

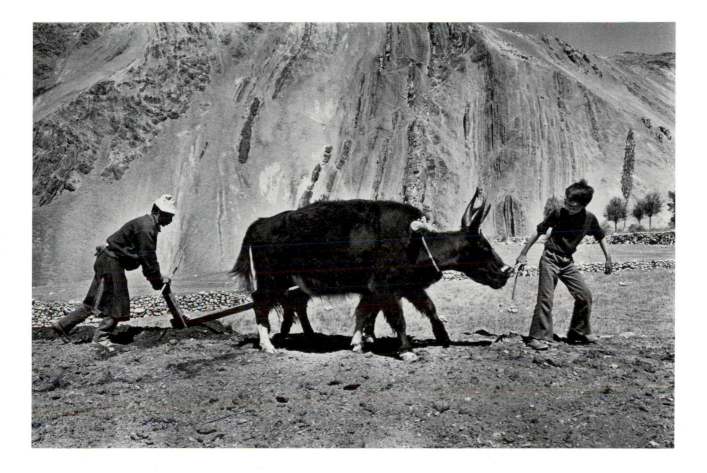

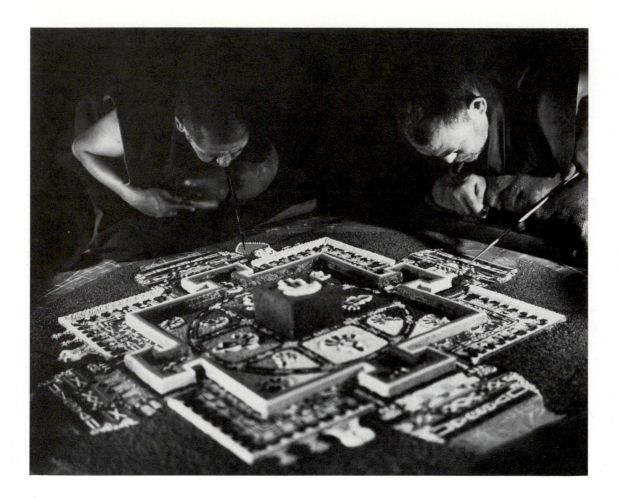

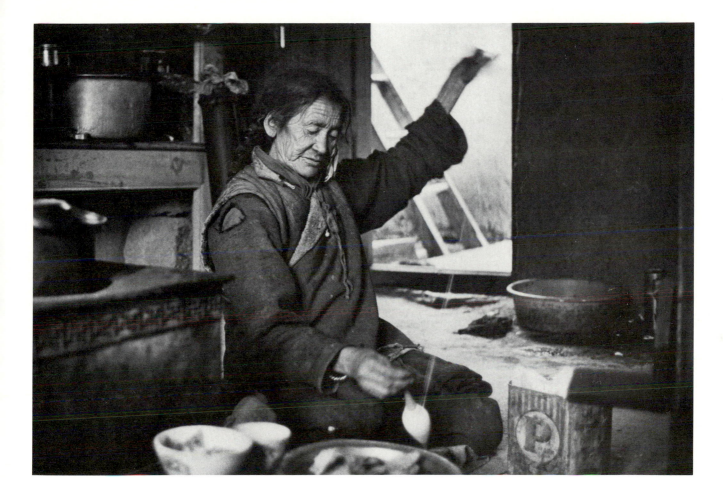

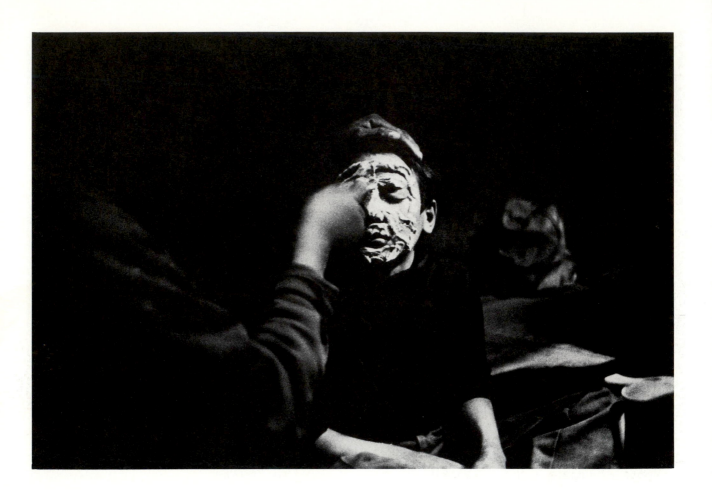

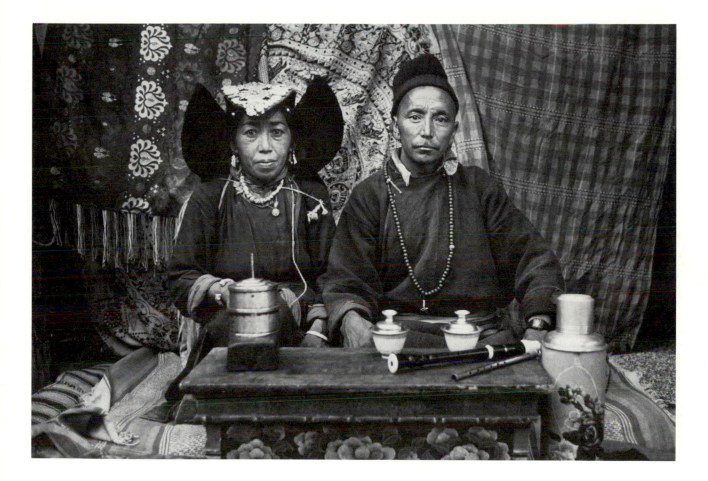

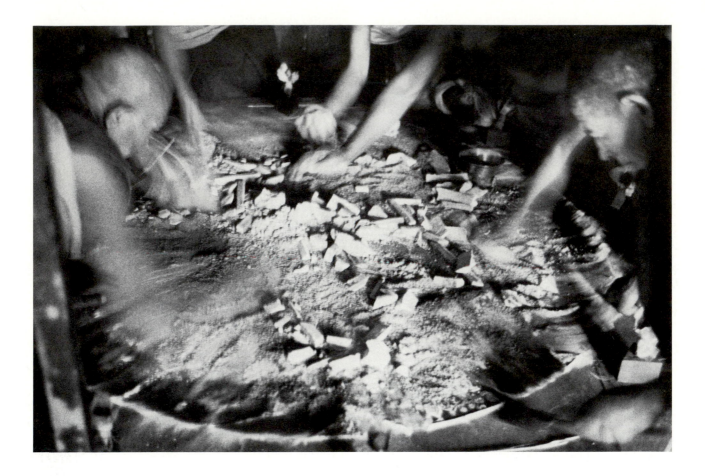

58 •

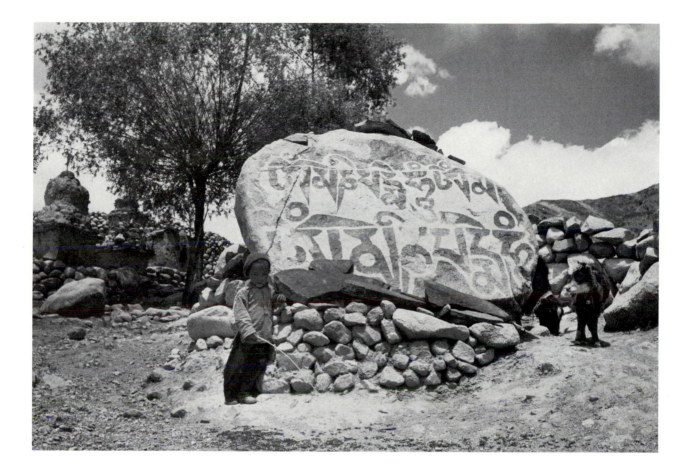

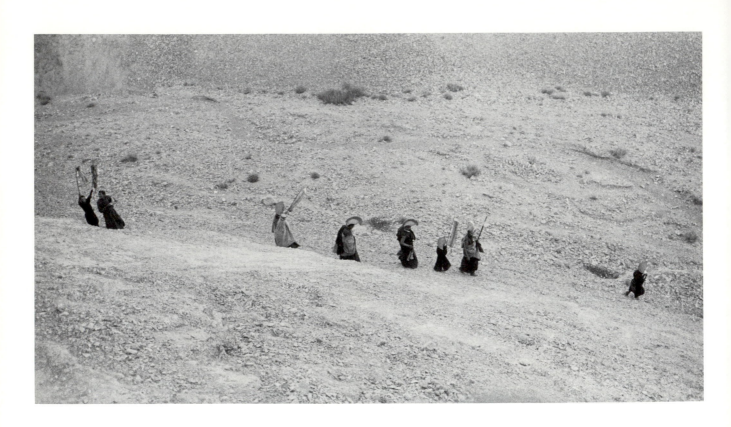

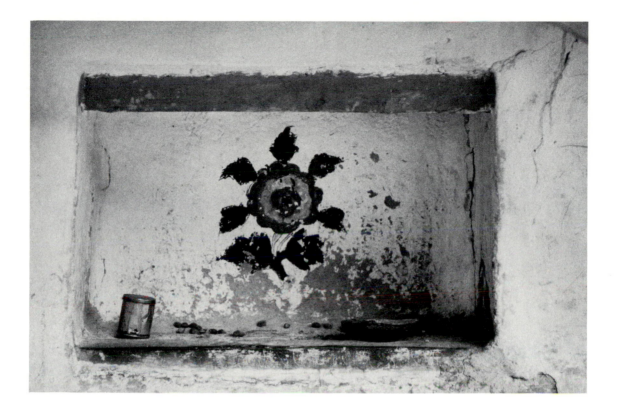

Ceremony of the Mother Field

he offers himself
without movement or sound
quiet grace
upon the imagination

He offers himself, holding his face still. His uncle applies the barley paste. Then each of us is handed a piece of barley flour dough, and as we accept it each shouts a saying. I shout, "*Jul-le!*" (Ladakhi greeting "hello" and "good-bye" that also means "thanks"), embarrassed that I cannot express more of what I feel about what is happening around me. I have become aware that barley has entered the darkness of the room without a corporal form: it is no longer a plant or crop for food. It radiates with its presence close to me.

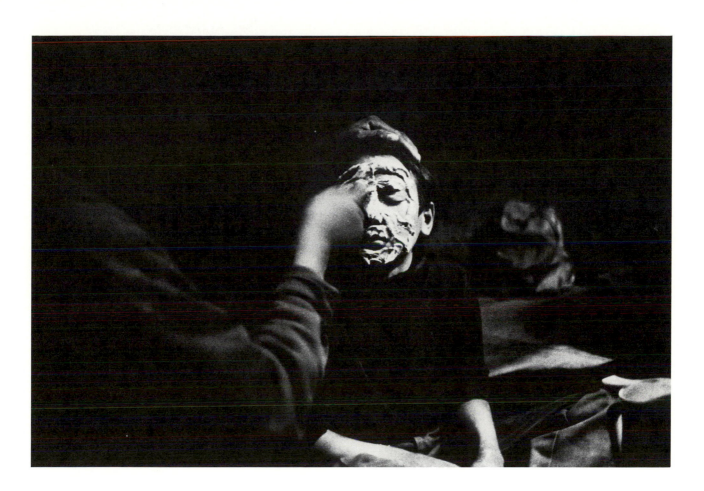

The men then eat, and joke, and laugh. The boy sits without movement or sound, taking into and expressing from his body the ceremony of the mother field. It is the boy and not the men who, maternally, must yield the fate of the field. I sense that the boy's quiet grace is not part of the ritual of the ceremony, but what he discovers and accepts from the ceremony.

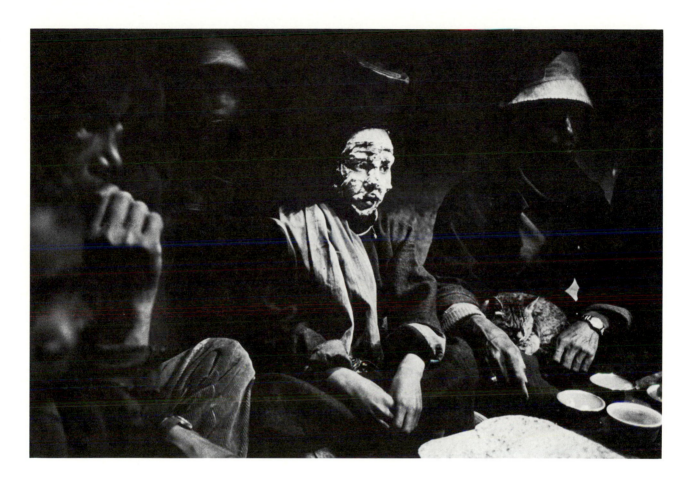

Ploughing

pulling the plough
and resting to feed
a rhythm of activity
among steps of my journey

The ploughing continues on the fifth day. There are rests. Different men take turns behind the plough. The boys leading the *dzos* (offspring from a yak and a cow) are exchanged. There are substitutions of these working animals into and out of their pairs as they take turns pulling the plough and resting to feed. People alternate with each other in raking and leveling the ground. People relieve each other in distributing seeds. Different members of the family at different times come to serve *chhang* (homemade barley beer) and food.

Through the day I find a rhythm of activity: people interchanging with other people, *dzos* interchanging with other *dzos*. I cannot tell if it is the heat, the intense sunlight, or the altitude that makes me lose a sense of continuity, but I cannot hold the parts together in sequence. And yet none of what I find is incoherent. All appear naturally together without a pattern but within a comprehensive flow; there is a movement without a discernible order. I lose track of time. I feel the heat. I say to the delight of the Ladakhis, "the *dzo* . . . my friend the *dzo*."

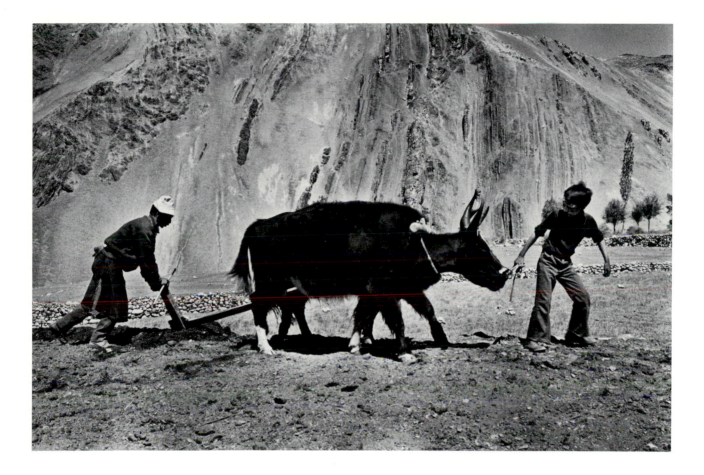

Spinning Wool

a single line
an arc
an unbroken circle

A continuous repeating gesture of arms, hands, and fingers. *Ama-le* (honorific title for a grandmother) sits, spinning wool for many hours, as people come and go.

The first phase of spinning creates a single line of a woolen twine. The second creates a spool of wool by extending one line into another.

Between the first and second phase there is a brief pause, a moment of arrested motion when torso and arms and twine form an arc. It is a necessary pause in which the body no longer acts upon, but is continuous with, the spool of woolen twine and spindle, as part of an unbroken circle. It is here that my understanding is permitted.

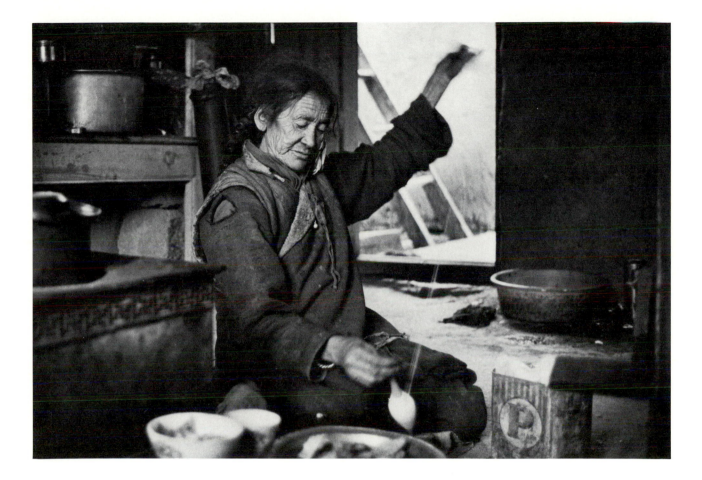

The Song

the source of the sound
the source of the singing
a child or two

Late in the day, the mother sings a long, melancholy song about the village from which she came. Near the end of her singing her voice becomes hoarse and weak, and she cries.

The next day I am alone with her husband. So that he may hear the song that she sang for me, I play the tape recording of her singing.

He listens intently, his face turned toward the machine, his eyes softly focused away from the source of the sound, but not from the source of the singing. He listens and weeps.

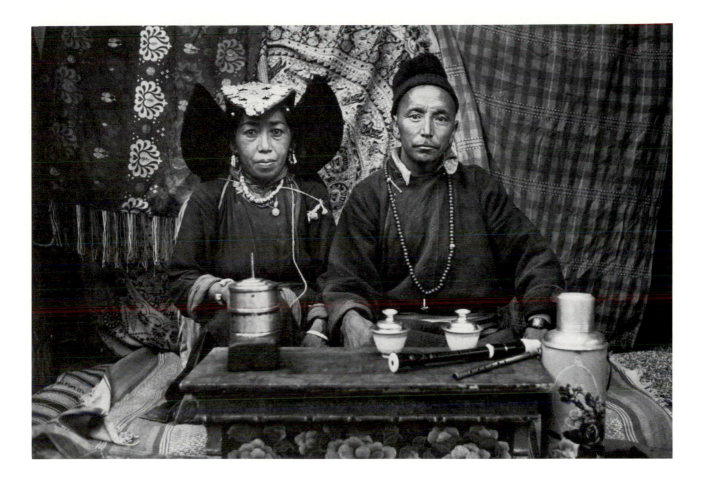

Chomo-le of the Village

treasures from afar
surrender their vivid colors
the first is a spinning
attention unmarked

On the wall there are two faces of babies, brightly colored, torn perhaps from wrappers of baby food, smiling, round-faced, rosy-cheeked, looking idyllic as found in pictures of babies of the 1920s.

These two faces surrender their vivid colors to a room of dim browns, grays, and powdery blacks. They are treasures from afar. Treasures from afar fill the room above this kitchen. In that upper room, a menagerie of photographs, lamps, cloths, bronze vessels of water—also, a place for sleeping. The day before *Chomo-le* (the nun) had taken one of the photographs from the collection, taken it from the upper room to the full sunlight outside and asked that I photograph its image: the Dalai Lama.

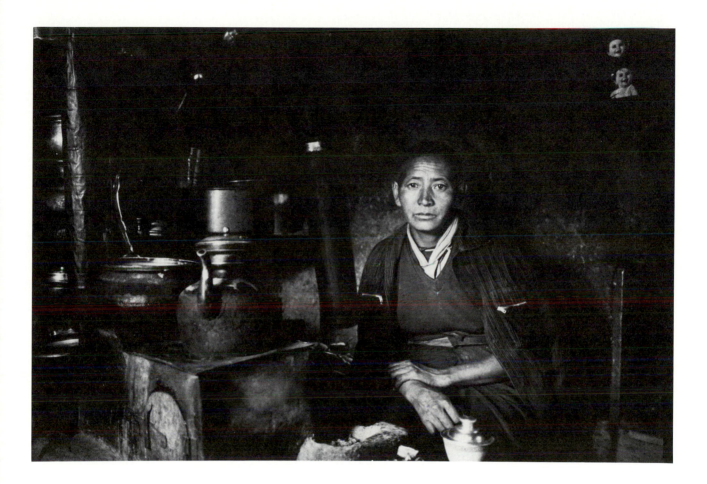

The Stove

the father returns
the faces of babies
the second creates
a pause on the path

The father returns from the fields. He eats, then prepares fresh *chhang* for me with a whisk, whipping fermented barley seeds in their liquid.

When in the fields or at home, whether engaged in an activity or not, the father's face is always at rest. Sometimes with a cloth he wipes the large black stove that sits in the middle of the kitchen. The movements are a stroking. The stove could be an animal or young child. All that he touches receives this care.

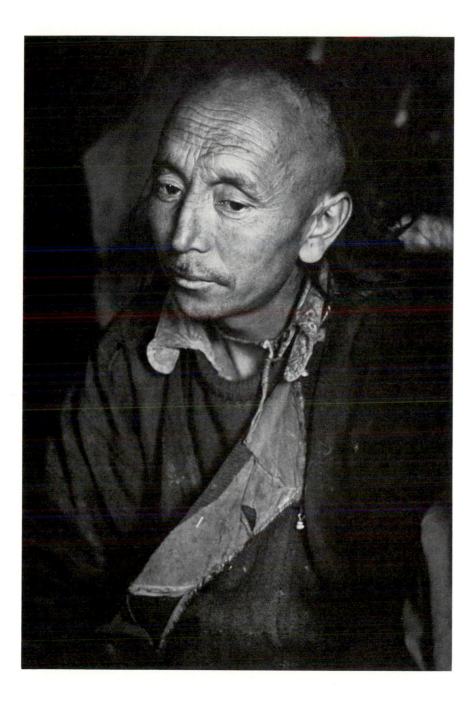

From the Eyes

to the eyes
an attention unmarked
a single line
a person or two

The men sit in a circle late in the day, having finished work-
ing on a wooden bridge. They offer me *chhang* and I join
them to drink and then to photograph.

When the face is isolated in the viewfinder, I am drawn to
the eyes. At first they appear sorrowful, but then as I linger
within that look I see that look is not sadness, but compas-
sion. This compassion is not focused on me either behind
or without the camera. This compassion moves forward
into a space within which I am and within which is all that
is animate and inanimate about me. My body relaxes and
receives the warmth of this look.

Somewhere, then, is the release of the shutter.

When the shutter signals its presence, there is no recogni-
tion of its sound in his eyes or in mine.

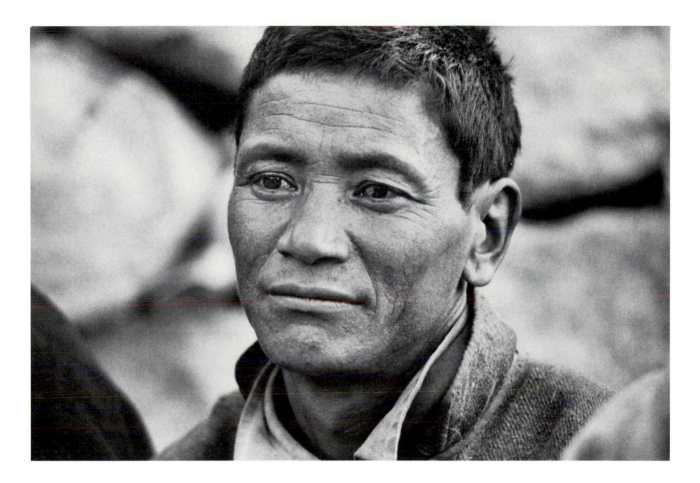

Lamas of Ridzong

an image emerged
the roar of the glacier
the eye as a witness
their bodies as shapes

I do not find a gaze and receive an aura from each Lama in Ladakh. Some are aware of me as photographer and of the camera as a recorder of their image. They straighten themselves for a picture and relax after they hear the release of the shutter. But the Lamas and novices of Ridzong were not this way. They moved about the kitchen preparing food and, later, polishing plates and pots with no sign of their identity of difference from me, the visitor.

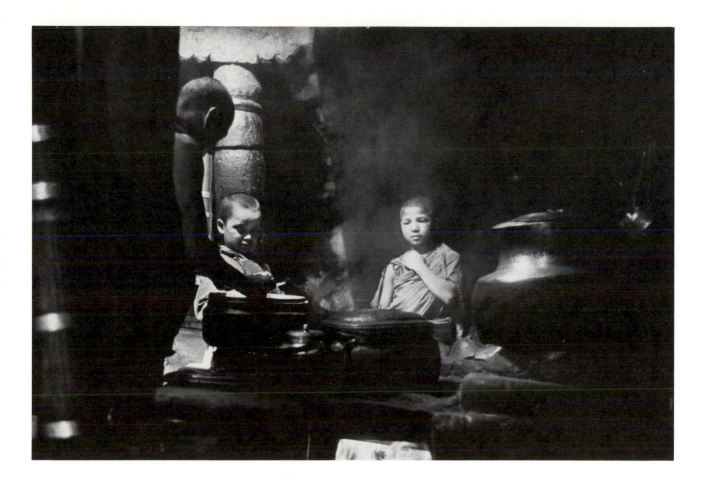

When I photographed them about the stove, I was aware of their bodies as shapes. Those shapes were so pronounced that I did not see, could not tell, what they were doing. These were human forms rather than social gestures, and these forms took their place with the shapes of the stove, shelves, jars, and other kitchen items. In this dark room with its one wide brilliant shaft of sunlight there was, first, a tonal harmony of forms and, then, an imaginal totality (a loss of particulars).

In a movement from one understanding (reality) to another, the eye, as a witness, is no longer only an organ of perception; it becomes also an organ of sentiment. The photograph must bear, if it can, a message of the movement of this witness between understandings.

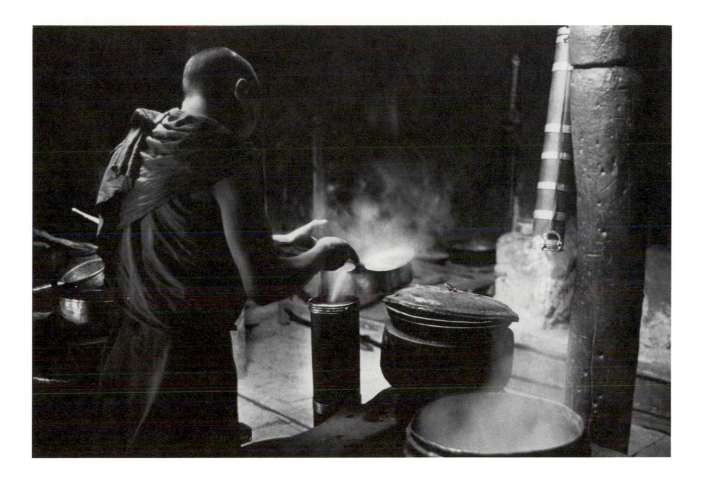

he offers himself
without movement or sound
quiet grace
upon the imagination

pulling the plough
and resting to feed
a rhythm of activity
among steps of my journey

a single line
an arc
an unbroken circle

the source of the sound
the source of the singing
a child or two

treasures from afar
surrender their vivid colors
the first is a spinning
attention unmarked

the father returns
the faces of babies
the second creates
a pause on the path

to the eyes
an attention unmarked
a single line
a person or two

an image emerged
the roar of the glacier
the eye as a witness
their bodies as shapes

difference is not strange
it has slipped away from me

traveling across
a changing landscape

following blended movements

hearing each sound separate

finding
in the frame of the camera

a moment of passion and
stillness

not seeking
what I receive and accept

in that silence
a discovery of form

this desert is inert, the potential
a recipient of melting glaciers
these waters are active, the creative
the source of nourishment

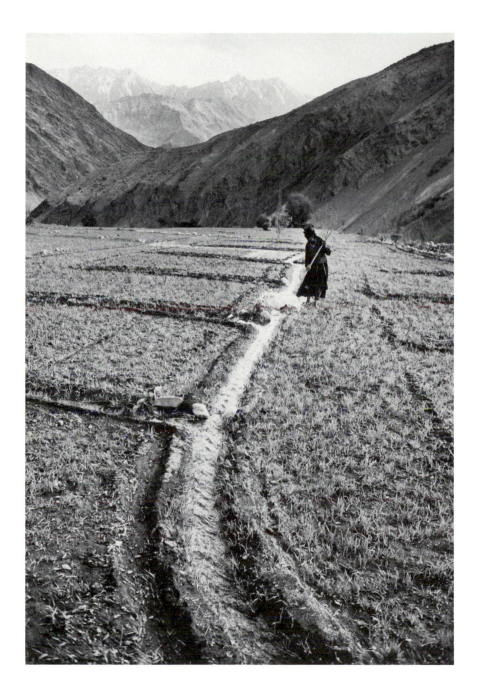

Mandala: A magic circle

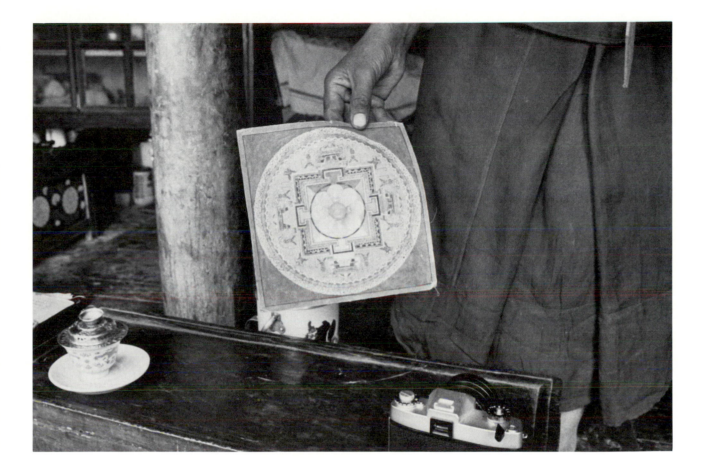

Mandala: A squaring of a circle

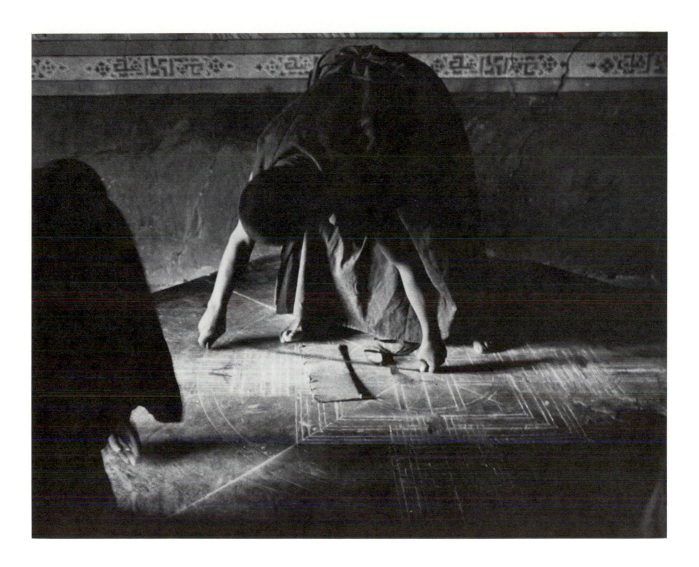

Mandala: A ceremonial offering

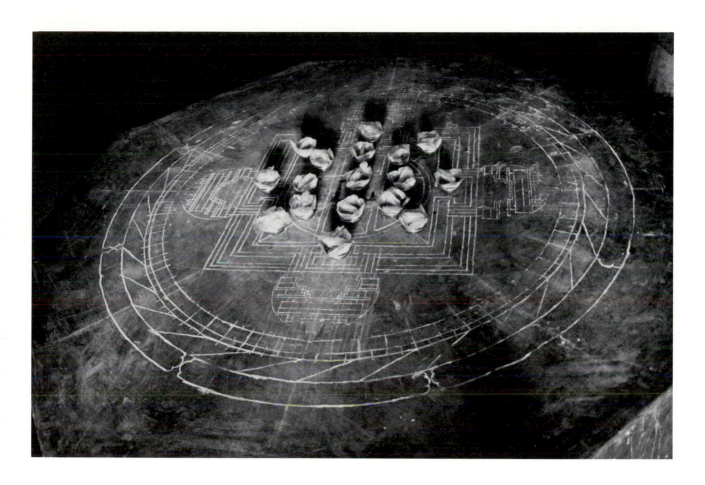

Outer mandala: A sand drawing upon a temple platform

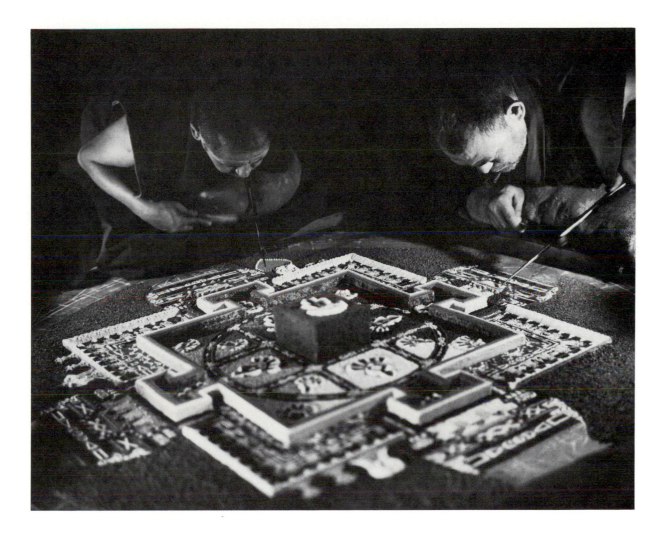

95 •

Inner mandala: A human body

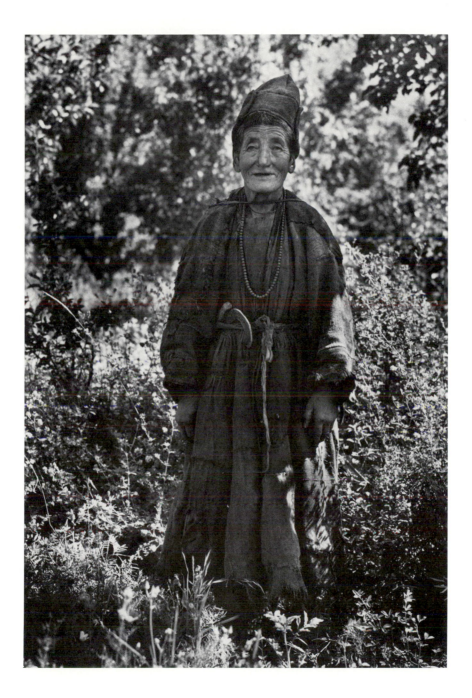

Secret mandala: A journey on a path

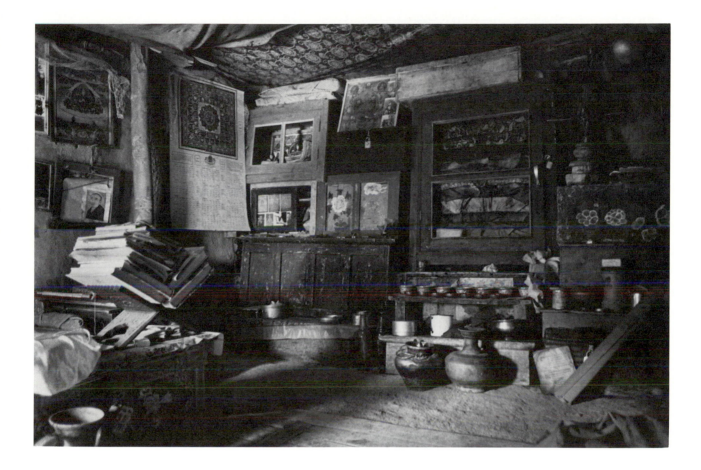

Mandala: A map of the cosmos

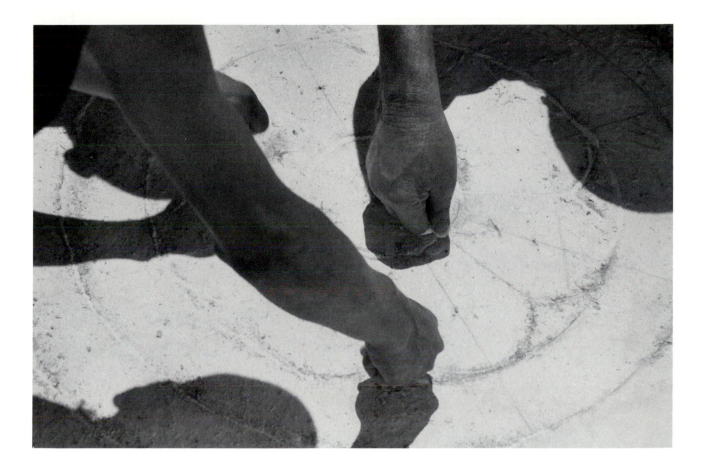

Mandala: A dream of disintegration

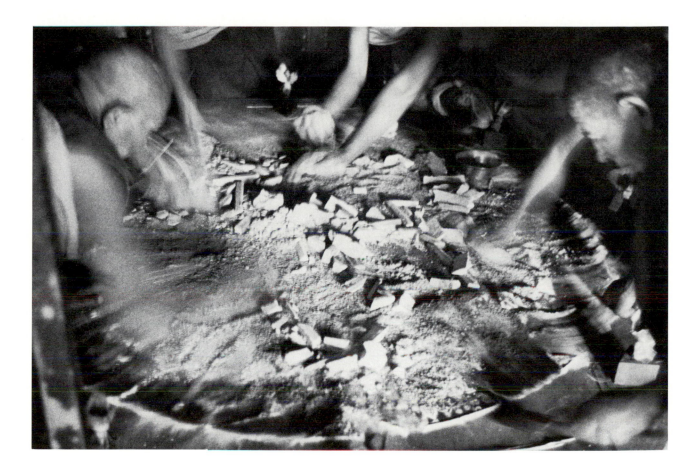

Mandala: A dream of reintegration

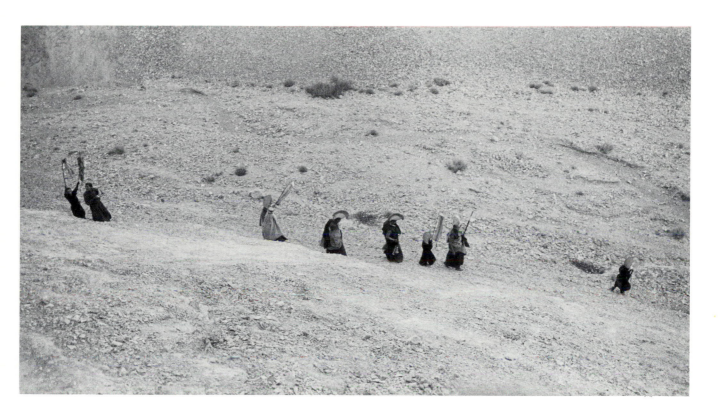

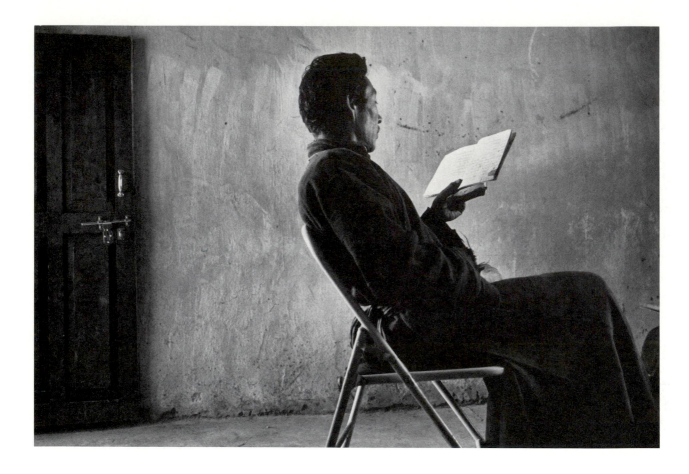

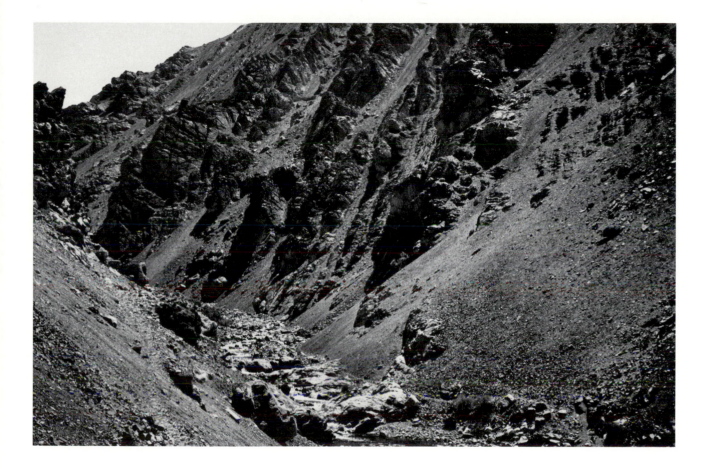

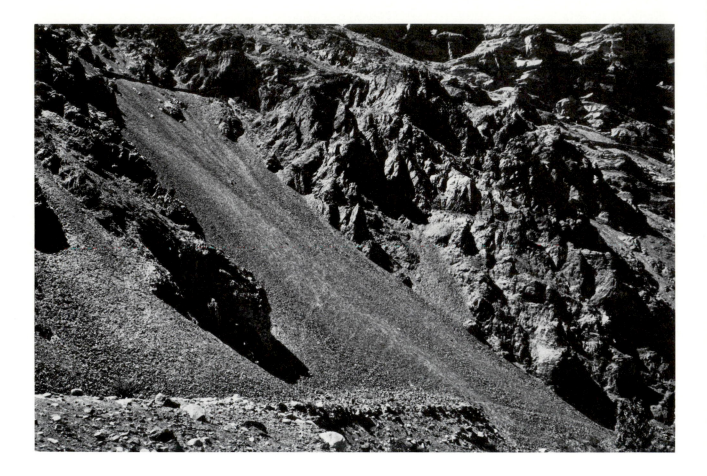

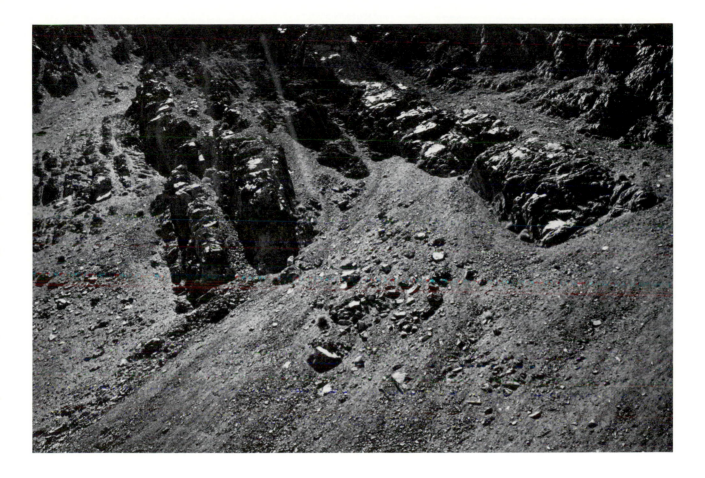

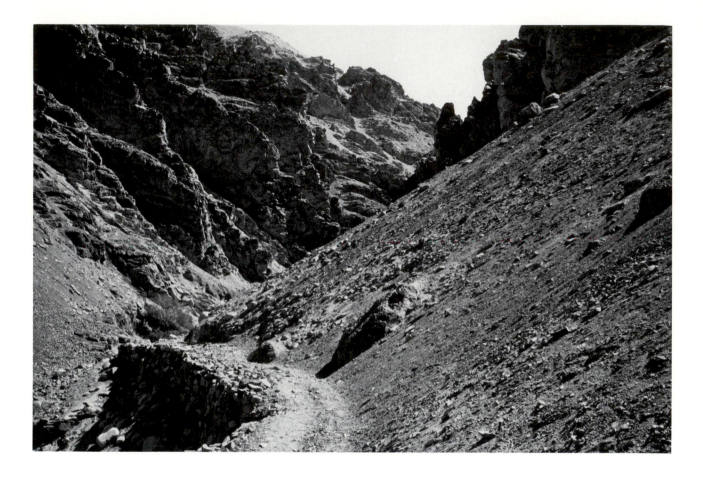

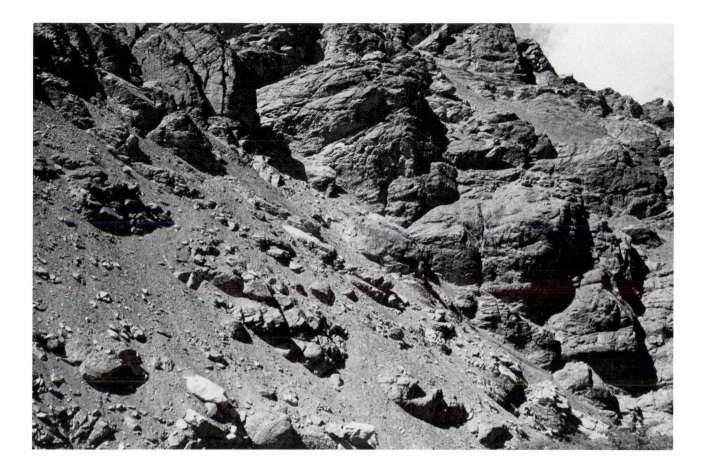

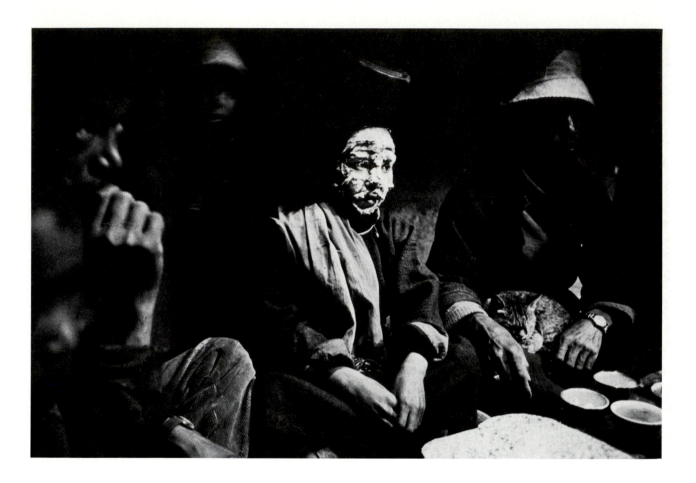

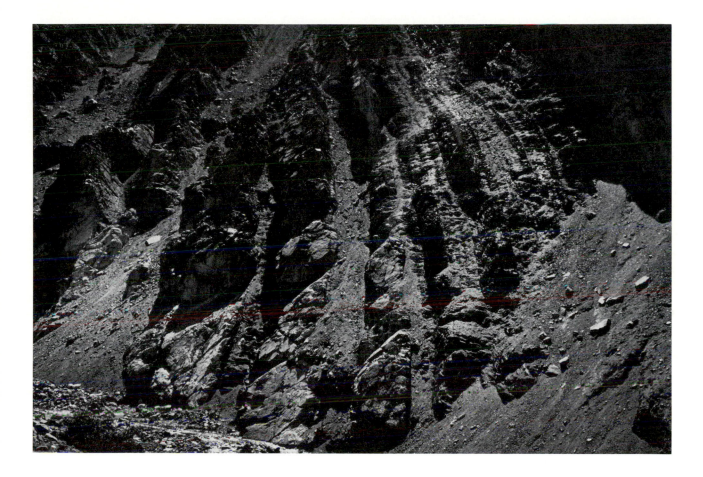

115 •

preparing for a journey; holds a bowl away from me; in my motionless body a pause on the path.

I follow the Lamas to the roof: They had only said "mandala" and pointed to my camera bag: When I reach the roof I find the midday sun washes away all detail and shadow: In this brightness I find there is preparation for a ceremony: Plates of grain and seed are assembled on a table: Sticks of wood tied together: *Yak* dung arranged to form the shape of a mandala: Rugs and tables placed in a row: Horn instruments lying on their faces: All of what is being assembled appear uniform in the sunlight: In a glare of a white-washed roof that makes me squint.

leaving Ridzong Monastery; passing on the way attention unmarked; a line of light; a diamond.

The ceremony begins: Plates of harvested grain are thrown into the fire: At times the Lamas and mountains disappear: I cannot see: The sweat runs down my face: Covers my arms: Covers the camera in my hands: My strength leaves me without an introduction of fatigue: I am brought out of action: Out of witnessing the mandala of the temple that was destroyed the day before: During this roof ceremony there is only the heat and the intense whiteness from the fire's smoke: images appear uniform momentarily and then are removed: I can no longer find the appearance of form: I have only the air of consumed images.

one by one in this stillness; in this stillness; a pause on the path.

their bodies as shapes; to avoid destiny and only the heat and the whiteness.

One day I was returning along the path to the monastery from washing my clothes and bathing at the glacier stream: I met a Hindi family from the Punjab: They had come by taxi from Leh and then had set out to walk the three miles from the highway to visit Ridzong Monastery: There was a mother: A father: A boy about eight: And the father's sister: Auntie: As I came along the pathway I found them seated on the rocks resting.

huddled to keep from the sun; this world is a dream; the many monastery steps; the river below.

passes on their way; are at attention unmarked; unmarred; a line of light; a diamond.

I stopped and also rested: They told me that it had taken them some two and a half hours to walk from the highway: A one-and-a-half-mile upward grade: They were very tired and could not imagine how much longer the walk would be: Auntie was breathing very hard: She referred to her extreme weight and said that she was not sure she could walk to the monastery but that she must continue to try as she had come this far.

one by one; in this stillness I am; this stillness.

I was surprised to learn that they had not drunk water along the way as they had passed a stream: I gave them my container of water: We then began to proceed to the monastery: Auntie could walk assisted by the mother and father only for some thirty yards at a time: Then she would have to sit down: Even the act of seating herself or rising to walk was labored.

**Some things are
so that: At the beginning
the facing parts: One after the other
are trouble.**

**Trouble to say what there is:
Which is then gone: one in the other
more choice than I intend.
To the end of reflection.
A world of words.**

At one of the rests Auntie expressed surprise at seeing me a Westerner staying at a monastery: We talked briefly about India and then she told me: I am Hindi and for us the world is a dream: It is only God who permits us to do things: It is He who sent you with your water to us.

Do I need saying? Would I stand as is?
Gaze has this voice present
so I remove the things.

We continued up the mountain path for over an hour in slow steps and many rests: When we reached the base of the monastery buildings Auntie and the boy stayed on a slope below while the mother and father accompanied me to the temple: I asked one of the Lamas for tea and food for the family.

do I need saying; would I stand as is? have not.

I sat for a few minutes in the temple with the father and mother and then we three began to descend the many monastery steps: Walking along the corridors and then down the path to where Auntie and the boy were waiting: As we passed the Lamas' rooms: Without comment they came to the railings of their balconies and handed me bread for the visitors.

gaze has this voice present; so I remove the things;

By the time we returned to the place where Auntie and the boy were seated a group of Lamas had arrived from the kitchen: They began serving hot buttered salt tea: *Taggi*: Which is bread made of barley flour: Butter: Sugar: And biscuits: When the serving began: With great effort Auntie got up from her seat and then knelt down slowly: Placing her head upon the feet of each Lama present including a little Lama of eight years old.

In the crevasse of the mountain rocks
huddled to keep from the sun coming down
the path: A mandala: An offering!

A line of light: Harmony between
roar of the glacier: River below

On my last day at Ridzong: One by one the Lamas came to my room: After a greeting and maybe a few words we would sit in silence without meditation or thought: In this stillness I was aware of their presence: No more: No less than their presence.

I leave the monastery after breakfast: In the kitchen there are good-byes and the Lamas give me a Ladakhi name: *Tashi Namgel*: Which means *Tashi* for good luck: And *Namgel* for full victory: Freshly baked bread is placed in my camera backpack and a little Lama straps my duffel bag to his back and we begin down the three-mile path to the highway.

As we rest near a river of glacier water two *dzos* with the Tibetan Lamas' baggage begin to pass us on their way to the highway: We stop them and tie my duffel bag to one of the animals and I continue alone.

Later: The two Tibetan Lamas and one of their students catch up with me and the four of us begin walking together: And then I notice that without intention the spacing between the four of us has formed a diamond as we descend a wide portion of the path: The eldest Lama walks ahead in the center of the path: Several yards behind him is the other teacher of the mandala near one edge with his student near the opposite edge: In the rear I too am at the center of the path following in proportional distance to the others: We are moving at equal distance and unthinkingly forming the shape of a diamond.

among the steps; an image; a pause; a bond of physicality; our eyes momentarily met.

119 •

Do I need saying? Would I stand as is?
I have not. Gaze has this voice present.
So I remove the things.

In my frequent walks to the glacier stream I met an old *Chomo-le*: She sat in the crevasse of the mountain rocks seeking the sparse shade from the hot sun: The cows she was attending searched for the little foliage among the stones.

The first time I passed her I nodded and she returned my gesture: The next time she asked where I was going and I used my few Ladakhi words to say to her: To wash: To the stream: She misunderstood what I said and gestured in the direction of the apricot trees.

In future walks I would look for the old nun as I rounded the corner of the footpath and came in sight of the place where I had first found her: And each time I would see her sitting there huddled to keep from the sun: Each time she looked different: Each encounter seemed to be an initial one: Each time a first meeting.

One day as I went to the glacier stream to fill my drinking container I passed the old nun sitting in her place: She said but one word: *Savon*: As the Ladakhis use the French word for soap: I had none with me and gestured as such.

On later trips to the stream I looked for the old *Chomo-le*: But neither she nor her cows were present.

Ladakh: Latitude 34.00 North: Longitude 77.00 East
38,000 square miles: 7,400 to 23,800 feet altitude range

The day before I left the monastery I came to the stream to bathe: As I was leaving I stopped to talk to a Lama: Then there: Coming down the path was the old nun: I handed her the soap I had in my hand as she passed by us: I did not stop my conversation and I was aware that the rhythm of her steps was never altered as she went by: Our glances to each other momentarily met.

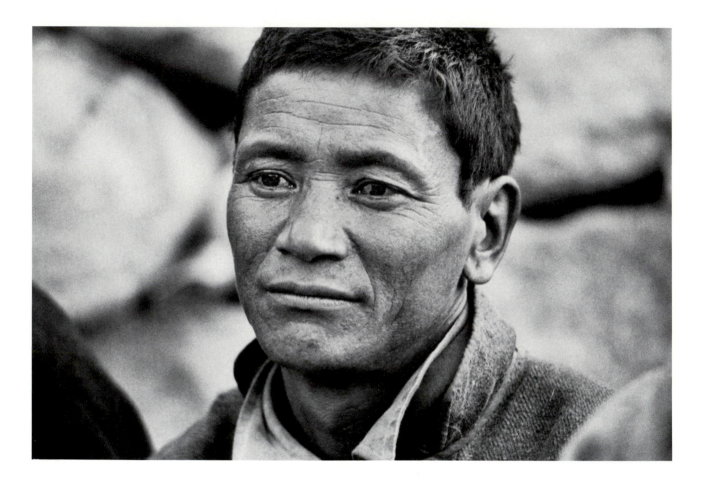

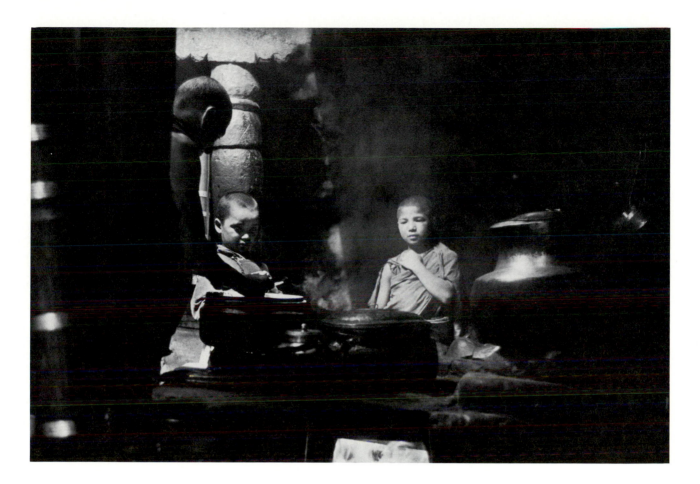

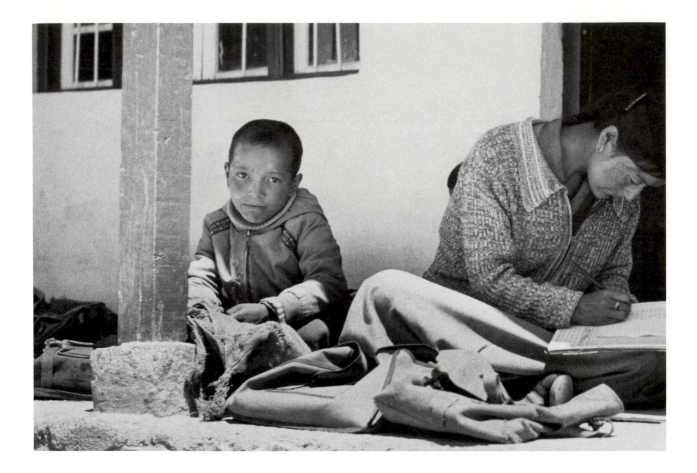

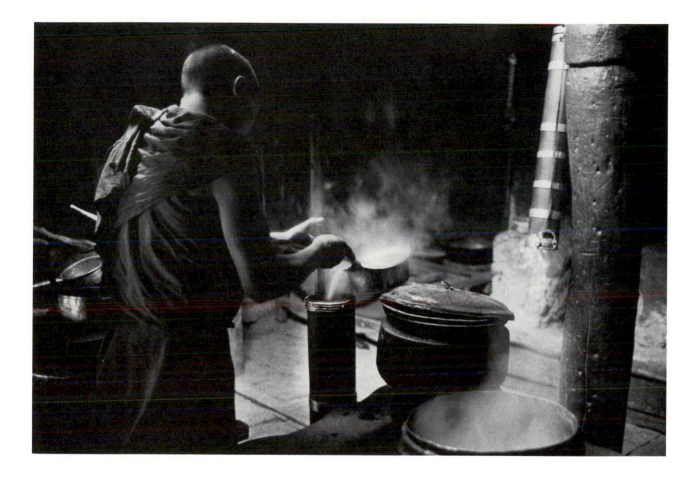

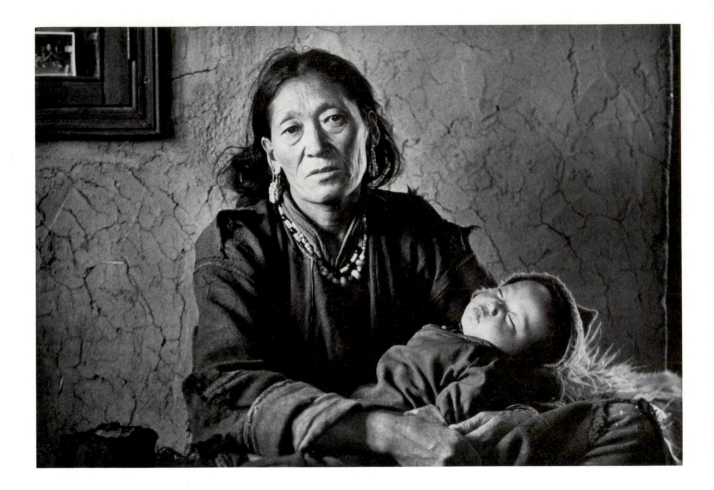

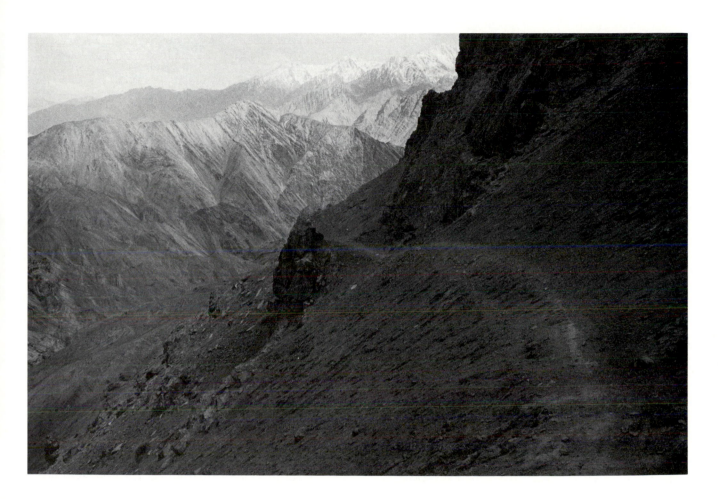

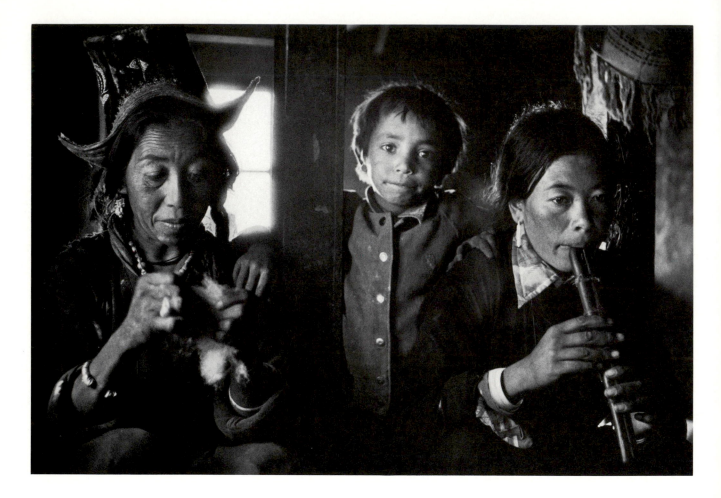

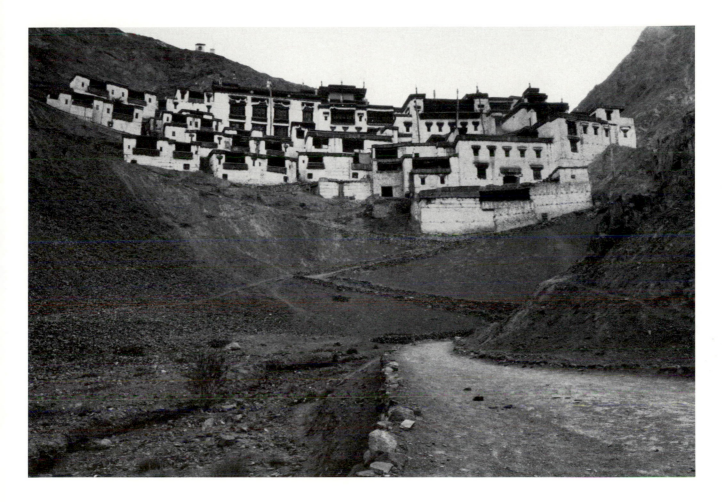

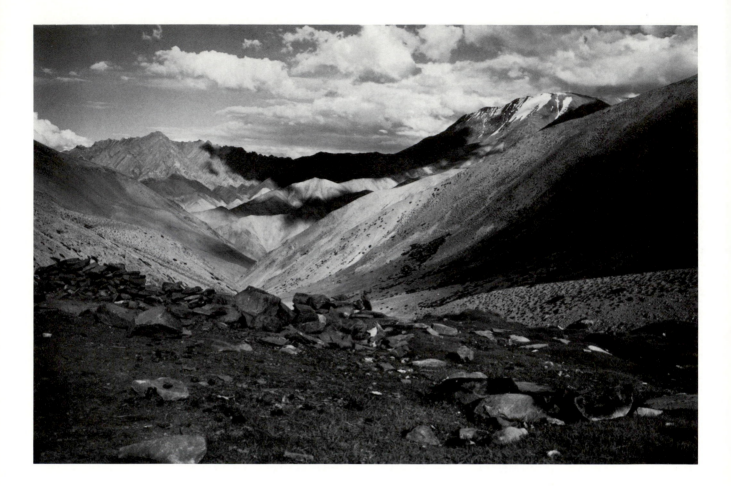

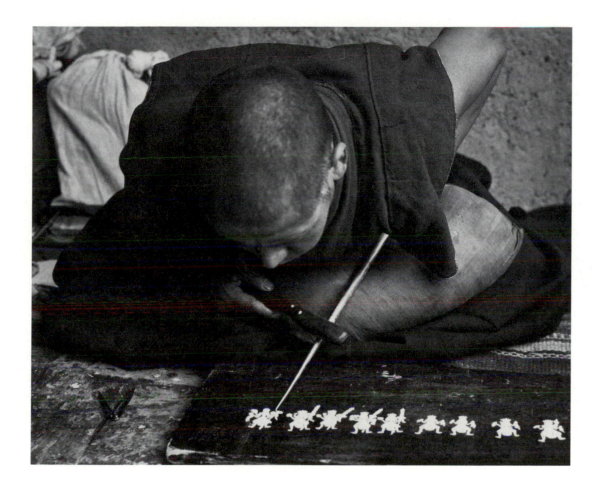

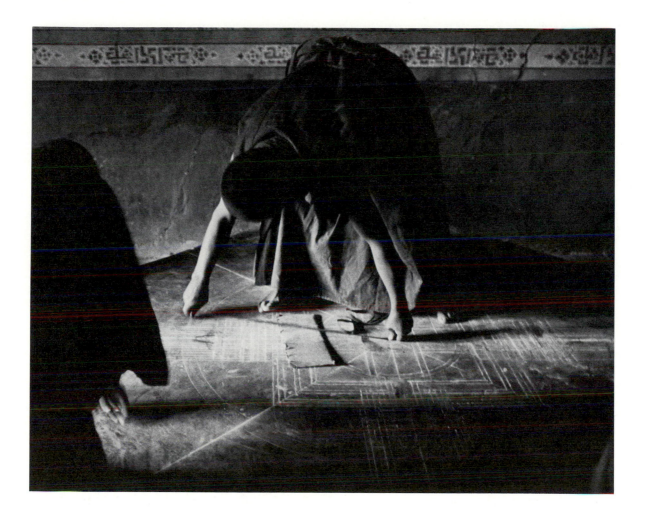

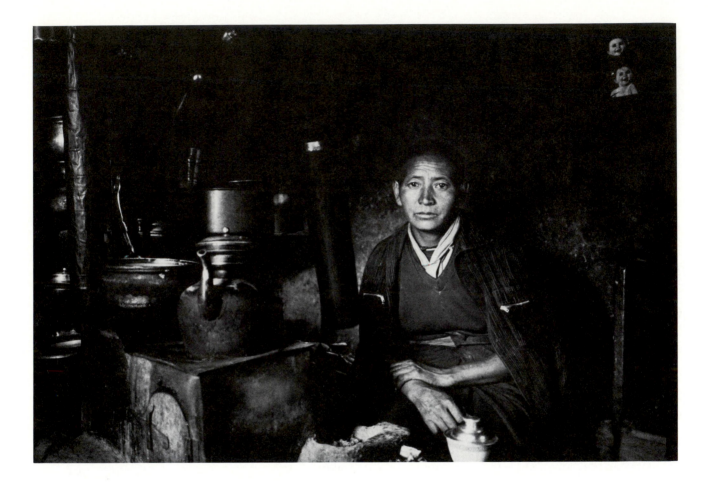

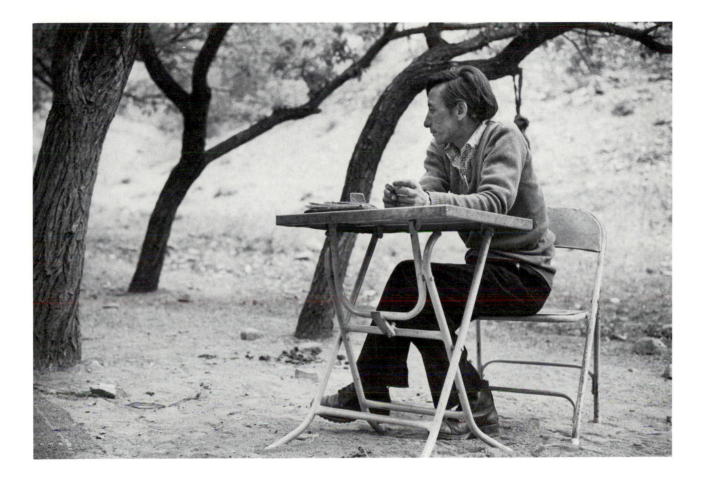

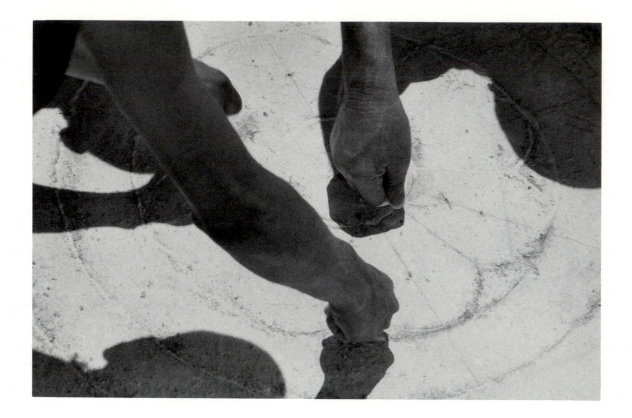

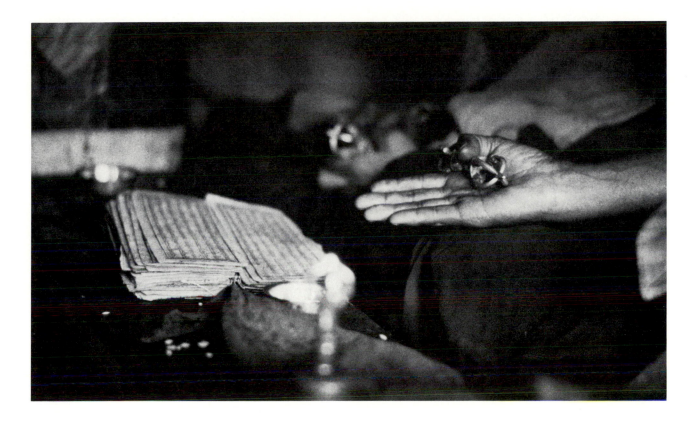

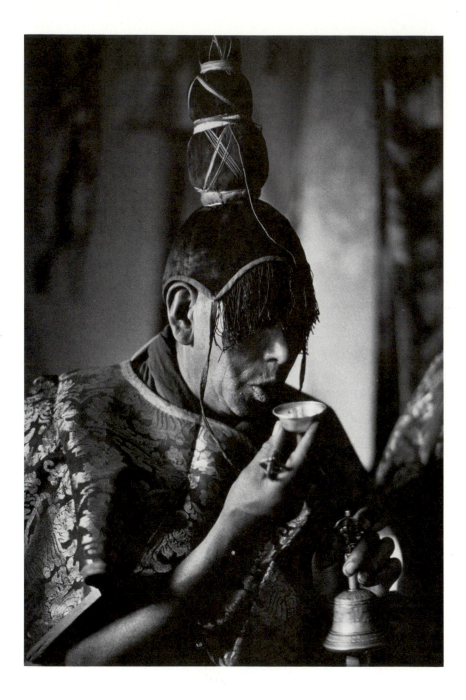

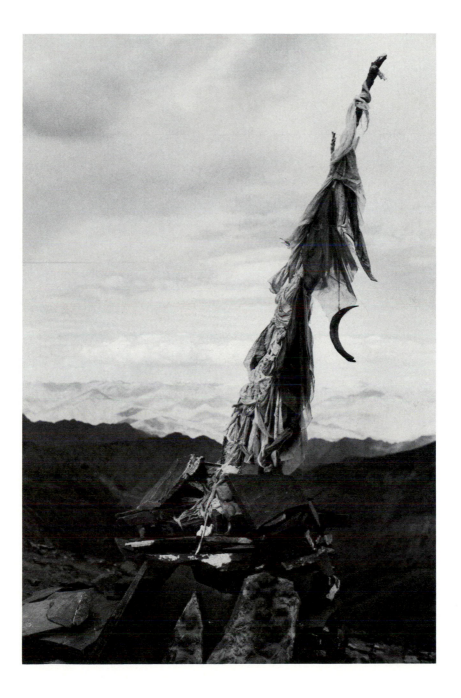

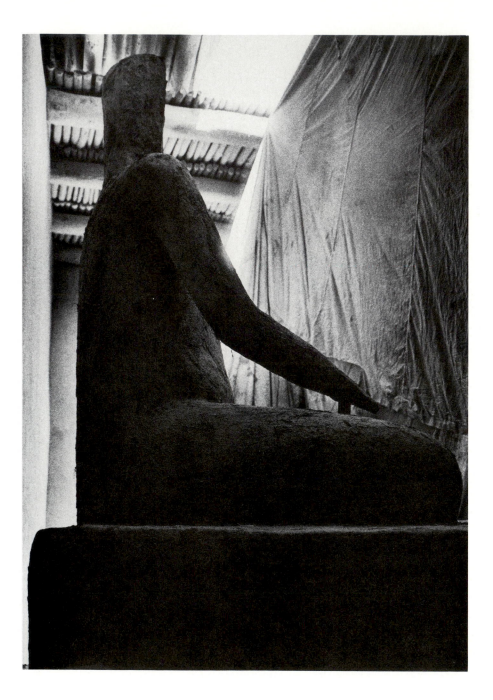

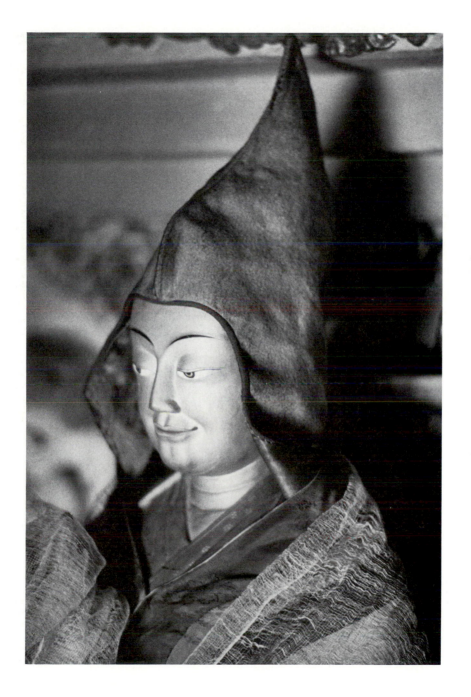

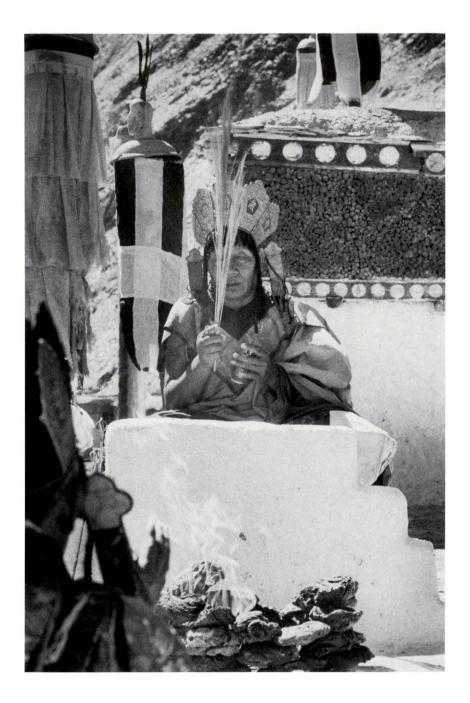

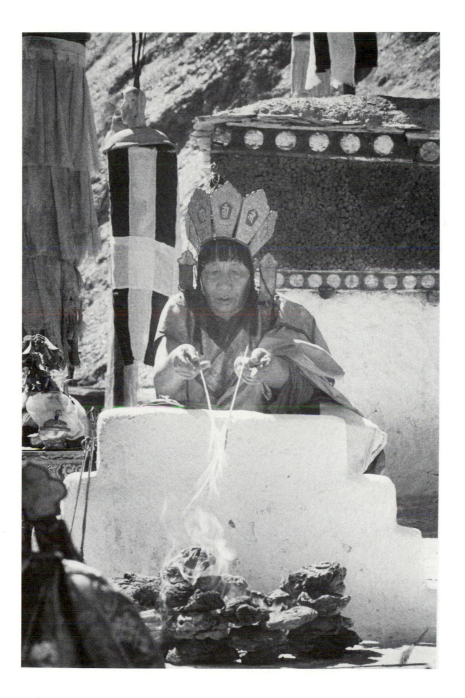

the desert is inert; the potential.

estrangement of meaning; pro-vided; permitted; and further and equal.

hearing resounds; invisible; each point a shape; it is here; the ground the focus.

silence and presence so as to find; outside disturbance; a point outside.

After the mandala was completed and enclosed in a frame of cloth there followed several days of prayer service in the temple.

On the second day a young Lama left the service and offered me some saffron and water that they used in the ceremony: He cupped his hands and gestured for me to rub the liquid over my face: I followed his suggestion: As I spread the saffron and water over my face spontaneously without a sound from my lips tears streamed from my eyes: I looked up to the young Lama: He showed me to cup my hands to drink the saffron and water: I followed his example.

The liquid had practically no taste but instantly I felt a powerful surge at the base of my spine as if I had received an electric shock: In my seated position on the floor: Leaning over the table as I drank from my cupped hands my body snapped upward from this spinal shock: I looked up toward the young Lama but he was already crossing the temple floor: Returning to the ongoing ceremony.

On each of the following days the young Lama gave me saffron and water: On each of these days I shed tears and felt a powerful surge at the base of the spine.

Also on each day I watched intently as he distributed the saffron and water to Lamas performing the ceremony: But I could find no such changes from them as I had experienced.

I am offered more and no more.
What I had failed to see is here:
The boundary: Again
necessity pointing: Pointing or bending:
One ground looked to a growing order.

places pause; other attentions move from them; look; see; time stop.

Stepping into ceremony: Stepping into recurrent time: A cessation in the movement of attention: Of not merely action but of the conception of the future in which recurrent time is happening: The future collapses into a singularity: The future is a still-space in which there is no forward time.

In a still-space a voice of gestures
a body resounds in a circle of ceremony
speaking a language of the body.

When I arrive at the temple on the first of the seven days of making the mandala: The Head Artist Lama gestures to me to sit beside him as he paints the mandala with sand: He places a rug near the raised platform on which the mandala is made and indicates to me that I may watch: Write notes as he has seen me do in the past: Photograph: Eat or even sleep: All this I was to do next to where he worked in the temple as he and the other artists painted from seven in the morning to nine in the evening.

A mandala is built by a slow laying down of sand: In the large temple of the monastery Artist Lamas of the mandala bend their bodies forward: Their faces a few inches from the surface of the platform: They work with a continuous movement rubbing a knife handle upon an undulant part of a tube containing colored sand: As the tube vibrates a stream of sand particles is left.

He sees for showing them in him.
He is what the rock says when it shouts:
The leopard: Death in dance: In devour:
Dancing men: Bedecked women: Lolling children.
He hunts: Not gathering and gathers into sight.

Movement and vibration are also found in daily prayers: In prayers there is a swaying of the body and a very deep almost gutteral sound from a Lama as that sound resonates in his chest and then as that sound is followed by a vibration of bells: Drums and cymbals: The vibration is present in the saying of mantras: The repetitive chanting of prayers: Often I would hear a farmer in a village voicing not words but sounds: A rising and falling humming at the back of the throat.

What can there be to disagree about?
He hears them breathing audible breath.
He hands over pictures
or does he?
Innocent stranger
or is he?

The movement and vibration of the tools for the mandala and the sounding of a mantra is the same as in breathing: I notice in my pause with Lamas a rhythmic cadence of their breath: The rhythm of breath's sound begins with a high pitch and then slides lower: Continuously to a level that dissolves in deep resonance of repose.

Again: As when the Head Artist Lama first told me what was to be made with his dancing figures I recalled the dream I had during my stay in the town of Leh: The dream in which a man approaches me on a path wanting me to see a mandala: Hearing my friend explain the world of Yamantika I became mute: Unable to share with him how I had in my sleep refused this mandala.

On the second day of the making of the mandala the Head Artist Lama pointed to the entire platform and their work and said: Mandala Yamantika: I did not know what that meant and I had to wait another day for my friend from the village to explain to me that this mandala was named Yamantika.

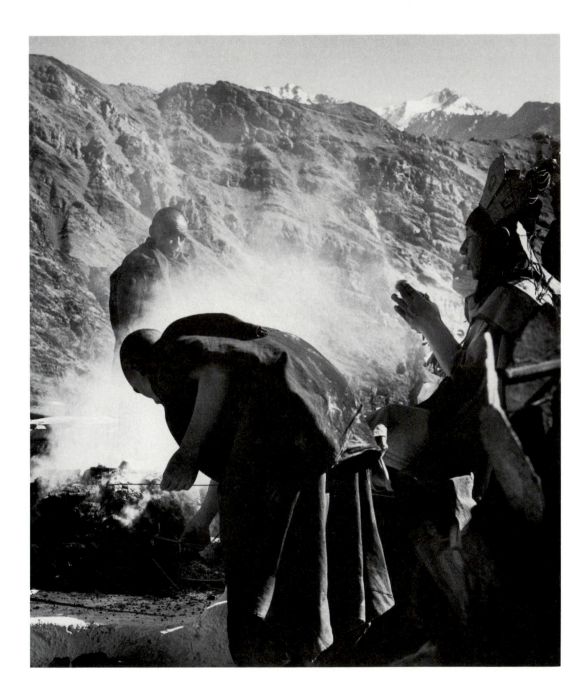

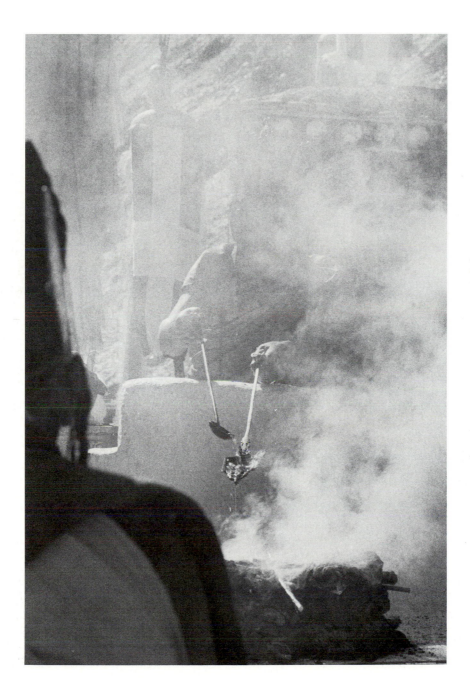

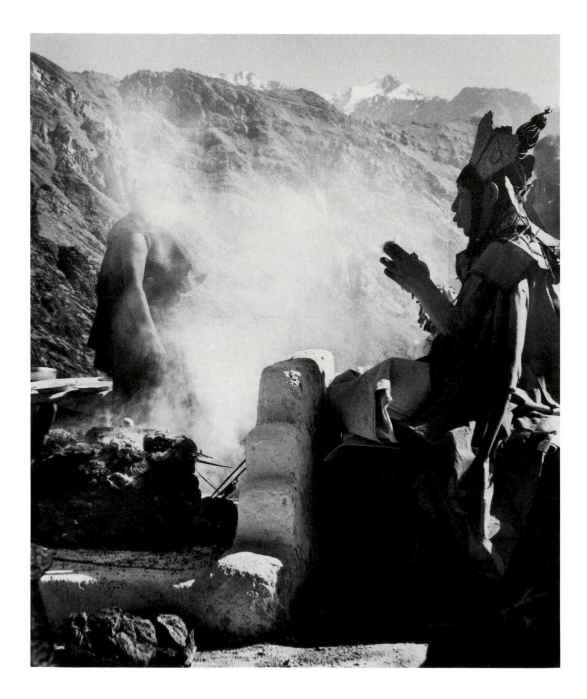

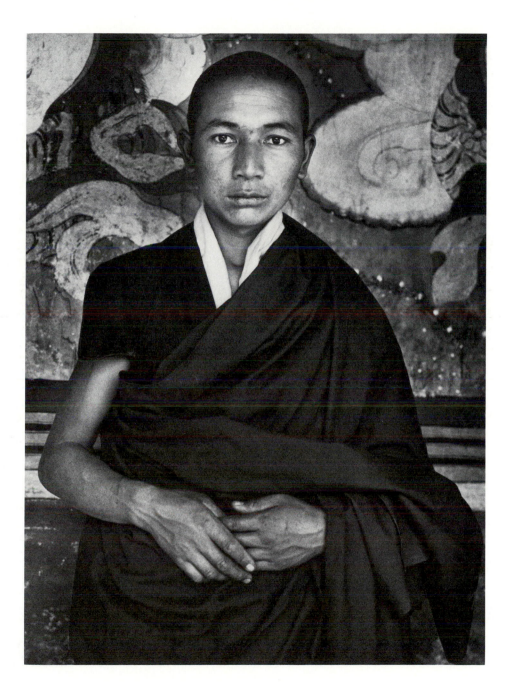

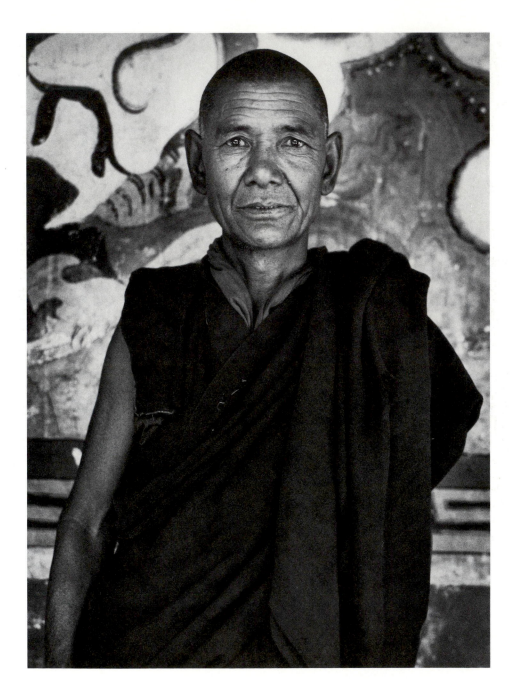

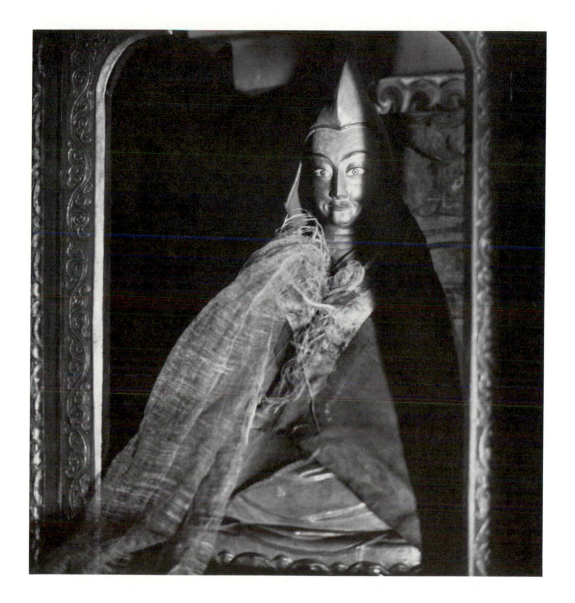

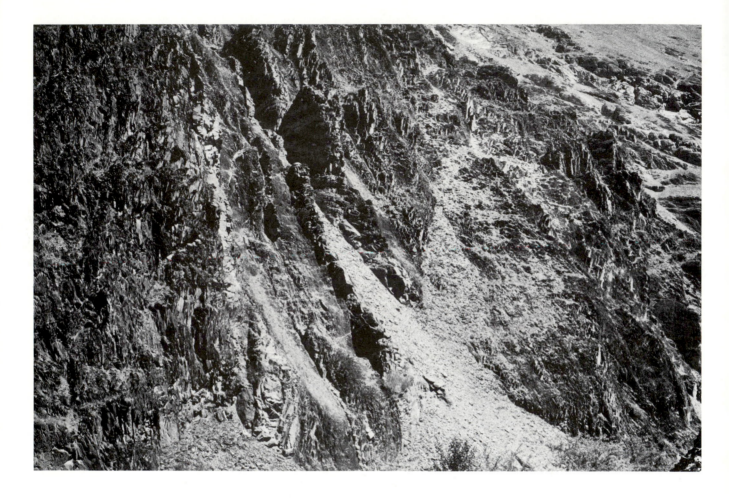

158 •

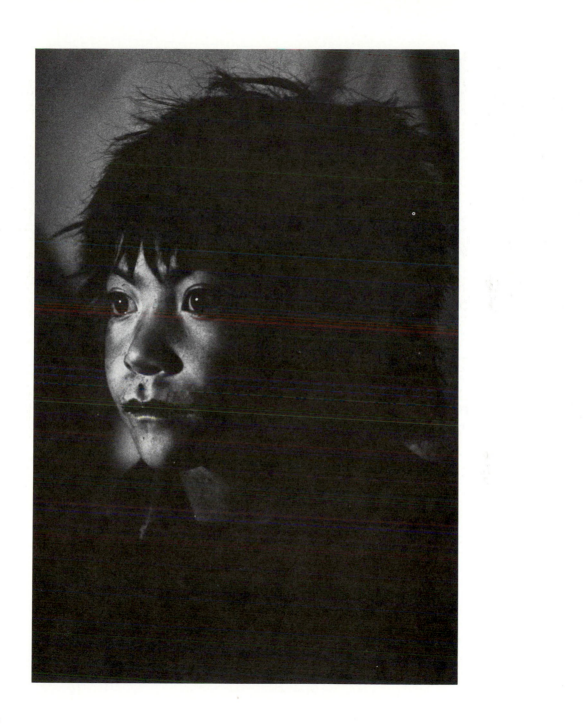

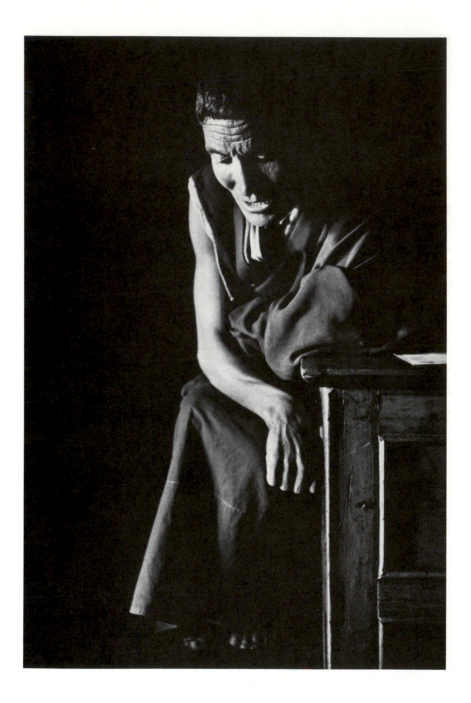

160 •

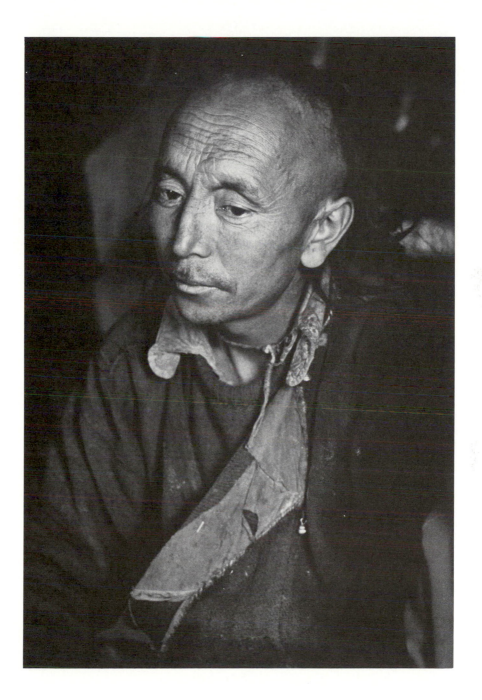

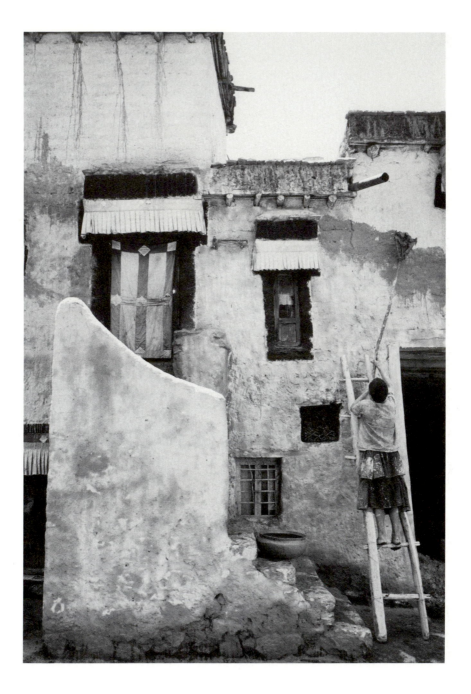

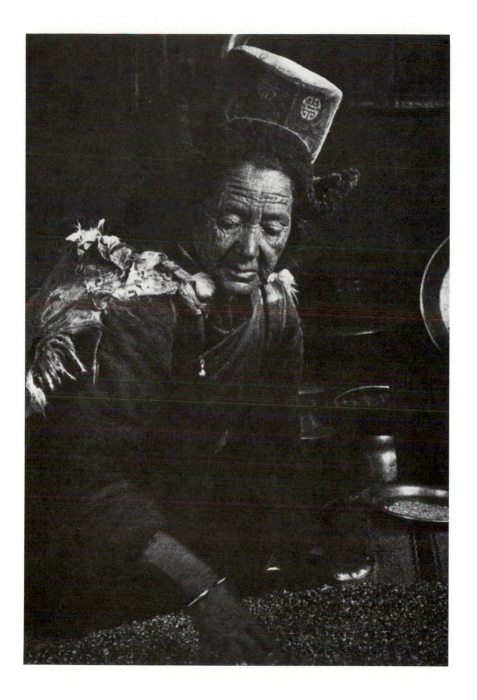

As one of the seven Buddhist worlds: Yamantika is the world where upon death the soul goes for judgment of past and present lives: A judgment that determines which world the soul will enter in the next life.

Upon my return to Ladakh: A dream in my first afternoon in Leh: A dream before I travel to the village and monastery: I am walking with a Ladakhi woman: A Ladakhi man comes to us: He has something in a box high upon his shoulder: He begins to open the lid of the box as he approaches: The box is flat: I know there is a disc inside: A mandala: I know the disc has colors.

the fire within does not glow by past; by anticipated futures.

I tell the Ladakhi woman: Tell the man to go away: She does but he persists in coming forward and opening the box: I do not want to see what is inside: I shout at him and wave my arms: He wants me to see and have what is in the box: But I refuse: He leaves.

I am troubled by this dream as I awake: The pressure of the man to see what is inside the box: Knowing what is there but not wanting to see it: I realize that I resist seeing a mandala that in my wakefulness I consider beautiful.

I do not know why.

before I travel.

one small window; holding hot coal.

to open the lid; the next words; eyes not looking.

I decide to choose one of the envelopes that my friend gave to me before I left for Ladakh: Perhaps the writing will instruct me about the dream: The note that I open is about the flame: Fire: The fire within: The fire from within goes outward to illuminate what we may discover: But that fire does not glow: Here there is not yet the quietude for it: My thoughts still wander: I am yet captured by the past and future.

never one thing; never one object; within a range of potential and successive possibilities; suggesting themselves.

their movement-of-attention revealed their belonging to an immediately and constantly changing world where actions take the course of potential that is offered.

movement comes to fruition in images other than originally intended.

My room at Ridzong is five by seven feet with one small window: It is located above the steps leading from the Lamas' quarters to the kitchen: The first morning following my arrival I hear the sounds of dogs below: When I look out the window I see little Lamas: Young boys from seven to fourteen years old in training for the monkhood: Carrying steaming pots of tea and tanks holding hot coals: They rush about making gutteral sounds that I have mistaken as animal sounds: Later I discover that this is the sound of a Lama leading a prayer service: In a prayer service this sound is followed by readings from other Lamas: Also by chants: Bells: And cymbals: It is this sound that calls all into ceremony.

Hearing resounds: Constrained: Taking hold.
Invisible: Each point of attention moves up
as a shape faced: Not silence.

No mention within: Silence and presence both
searching the source: Resaying.

We lose sight
we lose telling

I am offered no more
formless: The lines
invisible each
moves: Is silent

We lose telling
moving: Resaying
formed in the living

It is here
the boundary: again

And no more
ordinate attention
point to attend
within: We lose sight

And it is here
rare: Moving forward
formed in the life

165 •

dancing the sand; images in dreams; unspoken; unshared.

A Lama invites me to his room: He and another Lama seat themselves and begin drawing figures upon wooden boards: I face the Lama and the figures created by droplets of colored sand face me.

I point to the dancing figures and shrug in a gesture to ask: What is this? The Lama replies: "Mandala": Whereupon he takes out his notebook and turns to a page with a carefully drawn completed mandala: Mandala: I say looking at my watch again gesturing a question: The Lama counts five figures.

wooden boards; figures dance.

A mandala is to be made at Ridzong in five days.

As I look upon his drawing I am struck by a memory of my dream that I had a week earlier in the town of Leh.

I realize what the images foretold.

In that dream I was offered and refused a mandala but here in the Lama's room there is no one to tell: Here the images of the dream remain: Unspoken: Unshared.

**At 12,500 feet places stop
moments cease and almost see
other attentions move from them.**

a child; a tension; voices.

The teacher conducts a class from a chair and table: The setting is in a grove of trees: He is relaxed but somehow the lesson is not: He cannot communicate: Transfer: His presence to the children: He moves slowly even when he disciplines them verbally: They move quickly always talking in hushed tones that pierce the silence of the treed space: The lesson is a series of recitations read from books: A child or two stands near the teacher: One child reads: Then the second child reads: Sometimes the teacher reads the text and the children join in a chorus at certain words.

sometimes; solitude; a teacher.

Sometimes as he sits at his table and as the children are seated doing their lessons on slate boards he looks away into the distance: His eyes cast a gaze slowly there and then return to look upon the lesson: As with his voice there is only a barely discernible change in his composure.

In solitude: The teacher fills all space with his presence: In the lesson he fills only a line of space: Only an audible sign within a tension of voices in signaled repetition.

At 12,500 feet places pause
other attentions move from them
moments cease.

Look and see: Ladakhis!

Only change! Two rocks!
I will see about it
Rocks. Presence. Sign.

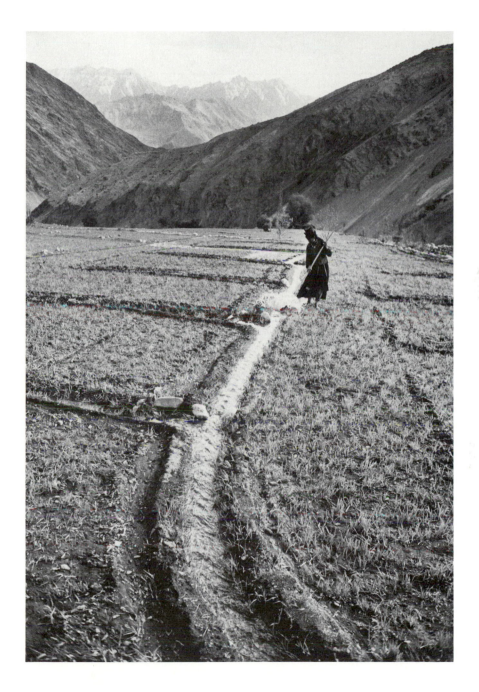

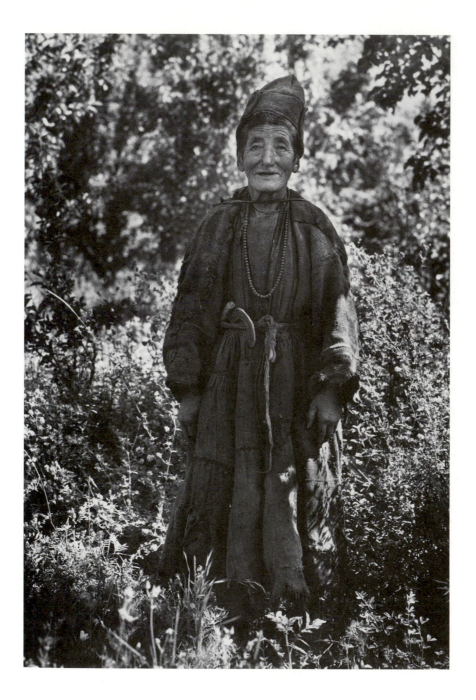

170 •

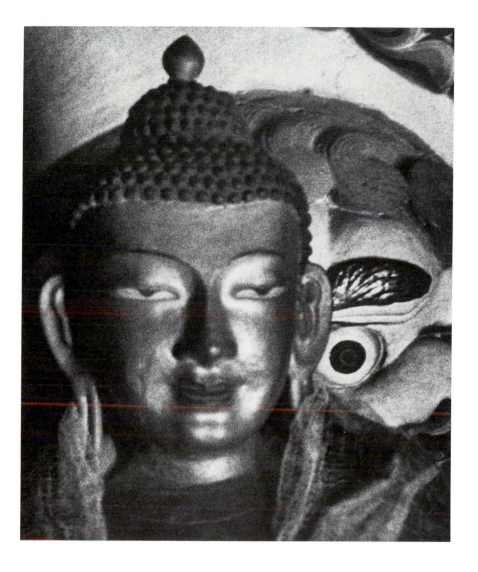

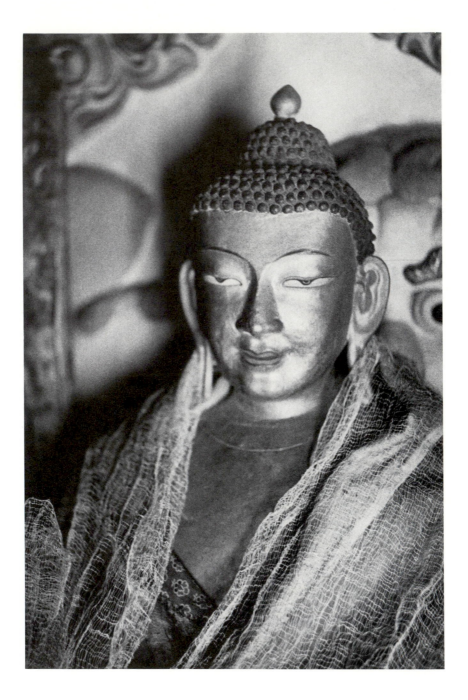

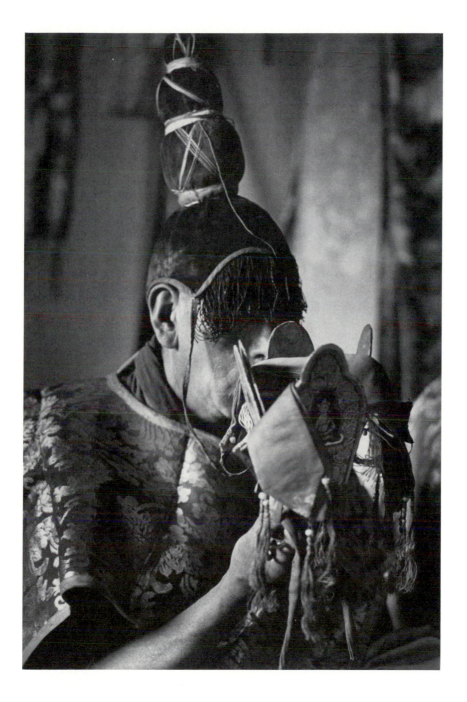

EPILOGUE

my function, no
I should rather say
my responsibility as a photographer/writer
is not so much to inform and explain
but most of all
to arouse longing
for a world
the reader has never inhabited
but has always known

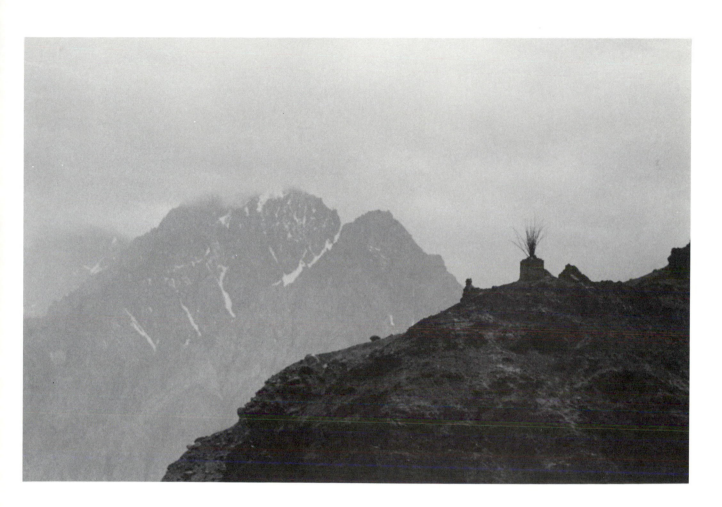

A Pause on the Path is organized around my experience of a journey within Ladakh. For me, the journey was not unlike early, pre-anthropological explorers' accounts I had read: descriptions of how travelers encounter worlds of earth and people wholly different from their own environments. Similar to these travelers, I, too, felt that I was adrift from my former biography and my heritage, encountering more than a change in place and of what is materially familiar. I had lost the very ways of identifying and judging what was new and wonderous within the midst of my travels. The journey to Ladakh became not only a crossing of physical and social boundaries, but a passage across another boundary that rendered impotent the traditions of modern Western reasoning I had acquired, shared, and contributed to in my own society.

I had no intention to enter into the cultural life of Ladakh. I had no knowledge of the indigenous language, nor had I prepared myself with an understanding of the practices of the people's traditions and everyday routines. And, even as I learned their ways and a hundred or so Ladakhi words through lengthy visits over three summers, I recognized that I was unaware of the subtleties of meanings. Yet all that was unfamiliar to me in Ladakh never appeared strange.

That I could enter an unfamiliar society and not experience it as strange and distant is what I regard as the most profound discovery of my journey: I understood the presence of the Ladakhi world as a dimension of basic human existence that I shared with them. This bond was present, for instance, during my modest assistance with their work in the barley fields—as I became aware of the immediacy of nature's cycles within the labor of our ploughing and our irrigating. I found mutual affiliation in the moments of our silence at family meals—as that silence underscored a communion whereby each of us was "within ourself" and yet each of us was most open to the others in the room. During the repetitive readings, gestures, and music of the temple ceremonies, I lost a sense of the passing of linear time. During my many days living with Ladakhis, I eventually slipped into a *liminal* region between the place of an outsider and the place of a participant.

My photography during this passage brought me to confront and understand the significance of the Ladakhi gaze. This look of unprotected and unjudging receptiveness appeared on the faces of children and adults. At first, I had been seized by the faces themselves as portraits of this quiet look. Eventually, I noticed how my photographing began to parallel the form of attention within their gaze. After entering a village, I would wait for my attention to settle. When I no longer looked and observed what people were doing, when I ceased to be struck by our differences, then I became aware of the flow of the Ladakhis' activities. Within the habits of their bodies, I would find moments of quietness, pauses of suspended activity. At such moments, in such pauses, there was for me a suspension of Ladakhi cultural meanings, an absence of all historically determined significations in their gestures. I came to know this pause as it was registered within me: I felt it within my

body as an unspecific physical resonance. With this signal, I became aware that I had entered into the liminality of the pause, a region where photography could become a medium of the same receptivity.

In this way, I was able to move through a functional tension of portraiture. In photographing, I became aware that my attention to Ladakhis' sentiment was part of their attention to their own activities. The photographic image was dependent on a union of what we each offered through our different engagements—they through their work or prayer activities, I through my photography. To bring the Ladakhis and my attention together, I used medium and short focal length lenses, which required that I be only a few feet from them. We were both aware of the camera. Yet the intensity of their engagement as it conjoined with mine overcame a self-consciousness or posing on their part or a hesitancy of intrusion on mine. At that point, similar to *rites de passage*, I felt that I had become a *liminar*, parting from a previous condition, and not yet absorbed by a new condition. I was suspended in a threshold, a region where I was no longer able to discriminate between my self and others.

In *A Pause on the Path* I attempted to express this process of liminality within photography and writing. The essay is a recording that organizes movement between worlds of cultures and separate biographies. Here photographic image is not an objective record nor is writing an ethnography. My presence in Ladakh was not an anthropological sojourn, but an *ontic journey*.

An ontic journey begins with an experience of foreignness whereby the traveler is without cultural foundation to understand and assess. It continues beyond this initial foreignness when the traveler loses a sense of intended

purpose (forgoes project) and surrenders to a resonance of place and others. Finally, an ontic journey refers to the traveler's return to his or her own former society and the attempt to describe the presence of that world which is "otherwise" in a manner that preserves the material differences of appearance, but does not destroy the universality of discovered human fellowship.

As an ontic journey refers to understandings within an interior reality, there is a special task involved in its presentation. It requires forms of discourse that are *expressionistic* in order to follow and represent travels within the subjective sphere. In composing *A Pause on the Path*, I felt that I had to carefully reflect my experience of liminality, but to do so, I had to depart from methods of the human sciences and also from a photographic tradition based either on absenting the photographer/writer, or on taking the role of a knowledgeable cultural overseer. My attempt in forming this essay was to create a work that will bring together a documentary tradition of a material report with an expressionistic travel account.

The term documentary, from science as well as from photography, and the term expressionism, from nineteenth and twentieth century art, may be considered antithetical. *Documentary* refers to a presentation of evidence, to a factual or in other ways substantive account that can be demonstrated objectively. *Expressionism* denotes a practice of distortion and exaggeration of objects and symbols in an attempt to represent an interior reality. A documentary focuses on a visible manifestation of what is witnessed, while expressionism emphasizes the sentiment of interiority of the witness. And yet, the two terms become entwined whenever we attempt to present to others images and descriptions that seem to stand outside our society's para-

mount reality and ideology. An expressionistic account in documentary form does not appear strange or without organization when we recognize it as unfettered by rules for understanding and explanation. The document of an expressionistic account is a record faithful to the place of its origin (in this essay, to an experience of the East). That document becomes post-subjective as a textual expression of its author, but the expression within that document does not account for itself through a common ground of knowledge that lies outside the author's subjective self. Instead, documenting an expressionistic account requires an author's interpretive process to be accountable first through a non-psychological reference to self and then by a release of the self into the zones of the sentiment of the body and the sentiment of the imagination. In documentary expressionism, body and imagination are accountable referents for images and descriptions.

In constructing *A Pause on the Path*, I have attempted to combine text and image in such a way as to elicit the possibility of an uncircumscribed reading of what was an uncircumscribed journey. I have tried to do away with a concern for authorial style and instead bring forth for the reader the presence and immediacy of a *call* of the essay (similar to what was a *call* of the journey). I have tried to avoid an author's re-call—which points the way toward a specific direction of meaning. The organization of this book is intended to release the reader into a fact of his or her experience, rather than into an aftermath of the author's interpretation.

In choosing and sequencing my photographs and writing I was guided by Roland Barthes' attempt to present ideas in essay form rather than as a report. I have arranged *A Pause on the Path* as a series of fragments of a journey within

Ladakh, fragments that accent my steps of both discovering and losing symbolic form in the midst of my travels. These fragments are chosen and ordered not for continuity and accumulation, but as self-sufficient sensuous and intellectual pieces in a cycle which resonate their relations. I have also been influenced by Roland Barthes' study of photography. Photographs in my essay are chosen to stand not as an average commitment to a symbol, but as images that potentially mark our sensitivity to what is within ourselves.

A comprehensive meaning of *A Pause on the Path* is to be found in its intertext—a region of space between the photographs, between descriptions of events, and between images and words. It is the intertext that acts to beckon with a common call, to claim the reader's thinking, and to draw the reader toward reflection and judgment. In the tradition of Barthes, my attempt was to create an essay of words and images containing signifiers as *sirens*. To create the essay as a signifier is to enlist the living effort of ontological hermeneutics. Neither a method nor a theory, ontological hermeneutics is a practice of interpretation; it seeks to create meaning in a reflective process that explores the dimension of what it means to be human. The living effort of ontological hermeneutics is to keep an essay's discourse vital within and through interpretation. Its task is to create meaning without assigning meaning, and to sustain an openness of images and words. My organization of this essay was to preserve photographs as subjects and to prevent a termination of their meaning—to keep them from becoming objects.

I have interrupted the narrative of my journey through village and monastery life in Ladakh, taken events out of their temporal sequence, fragmented the telling, engaged in all of these practices of presentation in order to create a cir-

cularity of meaning. An ontic journey is a repeating and circling to find a totality of its meaning. The sequence of photographs and sequence of written sections within the essay are formed to provide a sense of the movement of a journey rather than to offer a report about a completed journey. Within the organization of *A Pause on the Path*, there are practices of repeating what the traveler experienced, of encountering scenes along the way that appear to have been traveled before even though he is on this path for the first time.

The photographs of this essay are intended to offer an imaginal experience of Ladakh: they are rendered for readers to discover their own subjectivities, and to evoke a consciousness that registers a continual process of change. If this essay is successful, it will be seen to have *no message*. The meaning of the essay is silence itself in order to allow its readers to articulate a commonality of their journeys.

LIST OF WRITINGS

LIST OF PHOTOGRAPHS

ACKNOWLEDGMENTS

In the journey through Ladakh I came to recognize, similar to Oedipus, that although we may wander to avoid our destinies such wandering always returns us to them.

In Ladakh those I met who helped me recognize the tacit purpose behind my desire to explore were Sergio Cappa of Milan, Italy; Richard Purdy of Montreal, Canada; and Kalle Schröder of West Berlin, Federal Republic of Germany.

After my return from Ladakh those I met who helped me understand the significance of my journey were Yasha Podeswa and Ruth Simon.

Above all, it was Vivian Darroch-Lozowski who inspired me to embark on this sojourn, and who encouraged me to confront and accept whatever may be encountered within the journeying self.

Two people collaborated creatively with me in the forming of this photographic essay: Barbara Ivan, who organized the photographs and written text in keeping with the process of my discoveries; and Jeremy Taylor, who printed the photographs for publication.